Men in America

american

scene

Men in America

THOMAS FREDERICK ARNDT

Men in America is published with the generous support of the Horace W. Goldsmith Foundation.

First published in the United States of America by the National Museum of American Art, Smithsonian Institution, Washington, D.C. 20560, in association with D.A.P./Distributed Art Publishers, 636 Broadway, 12th floor, New York, NY 10012.

Series Editor: Steve Dietz; Series Curator: Merry A. Foresta; Series Advisors: Andy Grundberg, Alex Harris, and Anne Wilkes Tucker; Editors: Janet Wilson and Melissa Hirsch; Editorial Assistant: Abigail Grotke; Series Designer: Bethany Johns Design, New York; Layout: Abigail Grotke; Printed and bound in Hong Kong.

Distributed by D.A.P./Distributed Art Publishers
636 Broadway, 12th floor, New York, N.Y. 10012
Tel: (212) 473-5119 Fax: (212) 673-2887

Cover: Thomas Arndt, *Coffeeshop*, *Auction Barn*, Sleepy Eye, Minnesota, 1985

ISBN 1-881616-19-3

Library of Congress Catalog Card Number: 94-10911

Library of Congress Cataloging-in-Publication Data

Arndt, Thomas Frederick, 1944-
 Men in America / Thomas Frederick Arndt.
 p. cm. -- (American Scene)
 ISBN 1-881616-19-3
 1. Photography of men. 2. Men--United States--Social Conditions. 3. Masculinity (Psychology)
 I. Title. II. Series. III. Series: American scene (Washington, D.C.)
 TR681.M4A76 1994
 779'.930531'0973--dc20 94-10911
 CIP

The National Museum of American Art, Smithsonian Institution, is dedicated to the preservation, exhibition, and study of the visual arts in America. The museum, whose publications program also includes the scholarly journal *American Art*, has extensive research resources: the databases of the Inventories of American Painting and Sculpture, several image archives, and a variety of fellowships for scholars. For more information or a catalogue of publications, write: Office of Publications, National Museum of American Art, Smithsonian Institution, Washington, D.C. 20560.

American Scene

MERRY A. FORESTA
STEVE DIETZ

The photographic series is an accumulated vision. Based on neither a single defining moment nor the incidental snapshot, an extended sequence of pictures requires the photographer to choose a subject and stick with it over time. The problem of how to document a place, person, or idea is solved by an encompassing point of view made up of many images. For some photographers it may be the only way to describe—in the most poetic sense of the word—both hidden and well-known aspects of the American Scene.

"Who knows what America looks like, or who has seen more than a fragment of its face?" Berenice Abbott posed this question in her 1935 application to the Guggenheim Foundation for funds to document each state in the Union. The question is still being asked by today's photographers, each of whom has something special and particular to convey about his or her "slice" of the American pie.

The extended series carries the weight of intimacy. If our most contemporary luxury is a commitment of time, the photographer has invested heavily. The publication of these images in the form of a book enables the reader to be not just a witness but also a knowledgeable participant.

The goal of the "American Scene" publications is to present the evolving portrait of America of which Abbott dreamed. As the myth of the "melting pot" has given way to a social fabric woven into a "coat of many colors," there is increasing interest in how a photographer represents an individual view of the world to the widest possible audience.

Many earlier extended series, collected and published in book form, have become our best-known photographic masterpieces. Abbott's Changing New York, Walker Evans's American Photographs, Robert Frank's Americans, Aaron Siskend's Harlem Portrait and Bruce Davidson's East 100th Street have provided insights into the public and private aspects of a particular time and place. By combining images with texts, these books enlarge our perception of the diversity of American life.

The "American Scene" series is dedicated to working with photographers who have spent years and even decades photographing what they know intimately and with writers whose literary voices amplify the visual material. Like a "museum without walls," "American Scene" provides a unique exhibition space for photographic work well suited to the format of the printed page. In an era devoted to demonstrations of the increasing range of visual culture, this series of publications suggests that a simple, if traditional, format may still serve a purpose.

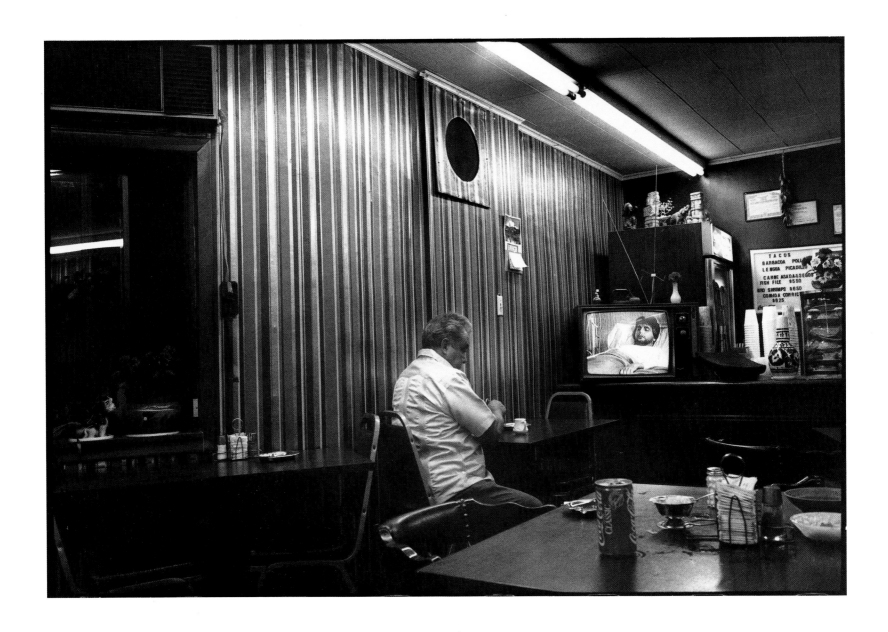

Man Sitting in Sabina's Restaurant, Chicago, 1986

Men in America

LARRY HEINEMANN

Men in America. Who are we? Go into the street and ask that question and you're likely to get all kinds of answers. We're an endangered species. We're clods, brutes, and scoundrels. We're loyal husbands and fathers, home-owners and taxpayers. We're alimony deadbeats. We fish the limit and hunt deer for the meat. We're vicious sexual predators, if not barbarians. We're shade-tree mechanics and Bondo body-work magicians. We beat our wives. We take a licking doing work that after thirty years leaves us with beat-up hands, bad eyes, and a bend in the back. We never grew up. Our fathers died before we were old enough to find out who they were, before we could tell them how much we loved them, before they could tell us.

We're lazy and shiftless; at the first sign of trouble we abandon our responsibilities and light out for the Territory. We work at jobs we despise because we love our families and always bring home our paychecks. We watch sports on TV, drink beer, don't lift a finger to help around the house, and never pick up after ourselves. We're nothing but cannon fodder, treated like meat and expected to behave like meat, and die before we're old enough to vote. We're not good at relationships, expressing our feelings, and positively lousy at nurturing. Why give it away to someone you can't trust, who just takes and takes and gives nothing back? Why me? Probably the dumbest question any-one can ask. Don't you know? It's your turn, bub.

The vulnerability of males at birth is a peculiar but well-established fact. I can't tell you why, but there is something about the act of being born—that remarkably beautiful and complicated process, excruciatingly painful, sloppy, and noisy—that's difficult for boys. Doctors who make babies their business know that more males than females are conceived, that many more males than females are stillborn, that male births take an average of an hour longer than

there is something about the act of being born—that remarkably beautiful and complicated process, excruciatingly painful, sloppy, and noisy—that's difficult for boys

those of females, that more males than females experience difficulties during labor and delivery, resulting in more birth defects and later developmental problems.

And while we're on the subject, what is it about black men that puts them at risk? As if we have to ask. Black males have the lowest life expectancy of any demographic group in the United States. The most common cause of death among young black men is violence from gunplay and the like. Black men are more apt to be unemployed or, if they work, to earn substantially less than white men, even with a college degree. One-fourth of all black men between the ages of twenty and twenty-nine are in jail. Has our culture simply written them off and abandoned them? It would seem so. Recently, when asked about his education, a young black guy said, "You tell me I'm ugly, so you put me in this ugly place," a falling-down public school in the Bronx. Why do other men in this culture permit this?

When boys reach mid-adolescence they are suddenly compelled to prove their bodies, to explore and develop a notion of courage. There seems to be a physical compulsion for this. To climb trees clear to the top, to run—mad-dash—the 440, to join the wrestling team and literally grapple with someone else equally determined. Mark Twain, speaking of Tom Sawyer and Huckleberry Finn, said there comes a time in a boy's life when he has a "raging desire" to go to the woods and dig for treasure. Hard sports and active leisure, rough-housing, seem calculated to develop those qualities most admired in young men. Strength, quickness, and keen agility. Endurance, concentration, and resilience. Love of contest. Trust in skill. The discipline to ignore physical pain (shove it down, push it back) in order to get the job done. All these obtain the respect and admiration of older men (and women, too), something a boy must have if he is to become a man.

The fullest exploration of these qualities of strength, wit, and confidence will serve a man well all his life until hard-won experience and accumulated wisdom take over. There's a running gag, worthy of a bumper sticker, that says cunning and guile (age and experience) will always overcome strength and

agility (youth and inexperience). It's a lovely myth. Along with the display of fledgling prowess, pride in the literally invigorating physical sensation of clean sweat honestly come by, and developing deft and sure mastery of healthy inner resources, there is sheer enjoyment in the effort and an appreciation of fierceness—the football linebacker stuffing a short yardage fourth-down play; the laborer pushing a wheelbarrow chockful of hundred-pound bags of silicone concrete around a construction site from dawn till dusk; a young smoothy calmly running the table time after time, shooting 8-ball against all comers; a father and son dressed to the nines for blizzard cold, walking through a frozen cornfield and waiting for the dog to flush pheasant and quail, shotguns at the ready. If you watch athletes, you will see them display, again and again, warm and casual virtually unconscious moments of male affection. In our homophobic culture it's an image otherwise rarely seen and enacted. They slap each other on the rear end and head-butt and high-five and solidly embrace every time they suit up. Why not the rest of us?

There are men and boys who see going into the military as a rite of passage. To be sure, this has always been a way to get off the street, up and out of the house, to "see the world," as the saying goes, and meet people from all over creation you would never have met in a million years. At its best it is young men in the company of older men, where women are excluded and male rules prevail (this part of the military ritual is no longer true, alas).

But let's take a deeper look for a moment.

Anthropologists tell us there are two elements needed for initiation: ritual space and the guidance of a wise and knowledgeable elder. But an enlisted men's barracks is not "ritual space" and a drill instructor is not a "ritual elder." To be sure, in basic training—boot camp—a boy learns the fullest potential of his physical self, the strange paradox of simultaneous cooperation and competition; learns to appreciate and join with positive leaders as well as how to avoid negative leaders; discovers and learns to appreciate, and cultivate, independence and leadership in himself. The boy emerges from "basic" in superb physical condition, sparkling with energy and calm in a newly discovered self-assurance. But a wide streak of misogyny is also involved, and a pervasive

racism that begins by dehumanizing an imagined enemy with words like "gook" and "sand nigger" and, in the extreme, ends with the spirit of atrocity that gives broad permission for massacre the like of the 200 men, women and children murdered at My Lai.

To be a soldier when you are eighteen, nineteen, or twenty years old is suddenly and dramatically to be connected with a brotherhood that stretches back to the epoch of the Iliad and beyond. Our images were buried at Xian. We mounted shaggy steppe ponies and galloped into southeastern Europe. We stood with King Henry at Agincourt. We defended our women and children when we rode out to meet Custer's 7th Cavalry at Little Big Horn, shouting, "Today is a good day to die." We died like flies at the Somme in France— 60,000 casualties in one day (the trenches smelling of rum and blood); it's still the record. We killed Jews for sport in Poland. We came ashore at Tarawa, face down, with the other gory flotsam at high tide—shot, drowned. We walked out of the Chosen Reservoir and, with every step, cursed the son of a bitch who sent us there in the first place. For all those thousands of years we have endured stupefying boredom, murderous sickness, wormy rations, endless filth, trauma amputation, disembowelment, hideous meaningless death, and the madness of sanctioned murder.

To be a soldier is to be connected with the very best and the very worst of what it is to be a man. Try as it might, and traditional opinion to the contrary, the military is hardly a ritual initiation by which boys are transformed into men. A modern army wants killers, not warriors. The infantry is many things, but it is not ennobling, enriching, or manful, believe you me.

In the biblical story of Creation, when Adam and Eve are expelled from the Garden of Eden, God tells Adam, "In the sweat of thy face shalt thou eat bread, till thou return unto the ground." Twas ever thus. Men have always felt the responsibility to work and bring home the bread; this is more than their traditional roll; this is the way of the world. And when a man is unable to do that, something goes out of him.

The late writer and educator Joseph Campbell said that you should "follow

your bliss." By which I take it that he meant you should discover what you love, then do that. After all, since you're going to be doing this all day, practically every day, why not pick something you like to do—pro-tour caddy, short-order cook, high-rise ironwork. If it doesn't exactly amount to bliss, any number of satisfactions are derived from a journeyman's skill.

Men in America are more often than not defined by the work they do: slapping fenders on Chevies, sprinkling Halloween Cinderella masks with glittering confetti, singlehandedly working an Iowa family farm, running a carnival Ferris wheel, driving a rapid-transit train. Asking a man about his work is a common way to begin a conversation. There is something about work and the satisfaction of work that makes a man feel good in his body, whether it's laying brick, tending bar, selling cars, or editing books. No one can doubt that men who work seem happier.

there is something about work and the satisfaction of work that makes a man feel good in his body, whether it's laying brick, tending bar, selling cars, or editing books

Men live by well-grooved habit. Getting up in the morning, going to work, coming home to spend time with the wife and children, going to bed, and getting up the next morning to do it all over again. It sounds hardly sustaining.

This culture teaches men to be stoic, to "suck it up and gut it out," to get a job, any job, and be breadwinners (never mind that it sends most of us to an early grave), to stifle personal expression and turn it inward—not a good place to focus aggressive (and probably negative) personal expression of whatever timbre or velocity. That's the sort of behavior that sends men to their rooms to eat their livers out for twenty years.

But what do men feel when their work is denigrated and diminished, as interchangeable as any machine tool on the floor, and valued at pennies on the dollar? What does a man say to himself, much less to his wife and family, when he's worked at the same job for twenty or thirty years, and then one day the boss comes around and says, "Got to let you go, sorry. Things could change, but don't call us, we'll call you"? What happens when a man is told that he may not do the thing he has been told all his life he must do? What

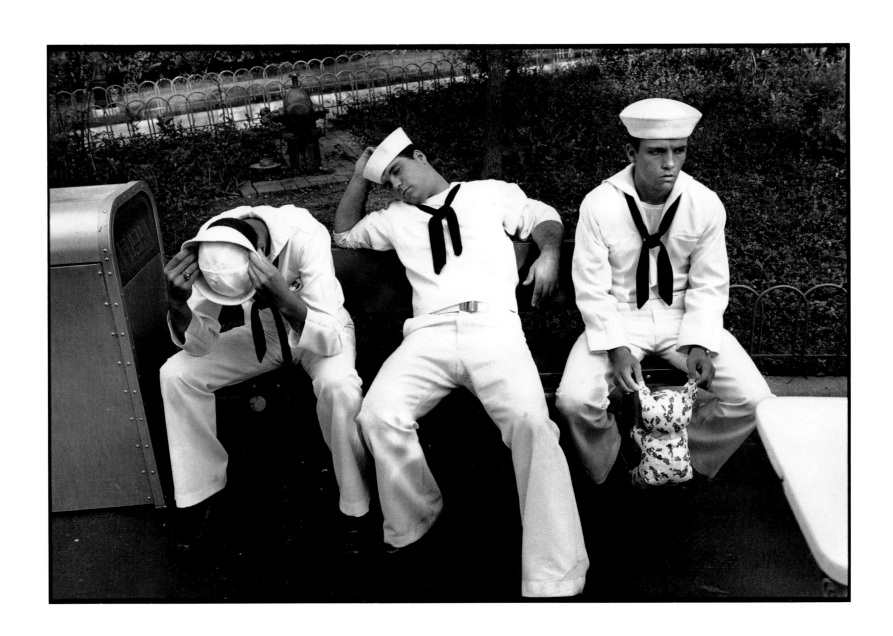

Three Sailors, Great America, Illinois, 1981

happens then? In recent decades when heavy-industry jobs began disappearing, when family farmers could not keep up with their mortgages payments and lost their land, these men began committing suicide, such was the despair.

Talk about habit. I know more than a couple of men who still prefer to roll their own cigarettes, and I don't mean Bull Durham shag. To be sure, it's cheaper, but that doesn't seem to be the point. Rather, I think it's the dexterous precision. Just the right pinch of tobacco. Just the right curl of the paper held in the fingertips. Just the right dry lick along the edge of the paper, the soft collapse of the whole thing at the first drag. What is that fierce enjoyment of something you know is killing you, but you smoke it just the same to feel it hit your lungs, to feel anything hit your lungs?

Take a simple thing like shaving. Simple, repetitive daily tasks should not be complicated, time-consuming, or expensive. I didn't really learn to shave until I was in my thirties—another one of those things my father never taught me. Nowadays I shave with a boar-bristle brush, a round bar of Williams shaving soap in an old coffee mug, and a twin-blade razor. There's something about regarding yourself in the mirror every morning that demands bluntly honest appraisal. You have to be sober to shave, and awake; it forces you to look yourself in the eye. You become intimate with every curve and curl, every little knot and notch, the very grain of your skin. It's a ritual done for its own sake—no one has to shave, mind you—and when you lean down over the sink to rinse off and again stand straight, why, you feel clean.

More often than not, men seem isolated from one another. Perhaps the isolation is the result of what Robert Bly has called a boy's "body hunger" for his father, that intimate connection all men seek to share, but few accomplish. It's more than "male bonding," which sounds too much like something you're supposed to do on a hunting trip, on poker night, or at a skin-flick smoker—a put-down. And it's more than being "buddies," another put-down. "Buddy-up" is something you do at Boy Scout camp when it's time to spend the afternoon at the lake swimming.

The connection that men seek is more serious than that, more fundamental and much richer.

Somehow what is most often conveyed in Tom Arndt's photographs is a striking loneliness. He has tempered the portraits with obvious affection, almost a sweetness, but not the sugary kind. It's more like when there are men on first and third, and the third-base coach calls for the suicide squeeze. The pitch comes (a fastball, high and tight), the man on third breaks for home, and you square around and lay a bunt down the third-base line. The ball stops dead in the grass just before the third baseman can get to it, and he muffs the bare-handed pickup anyway. The play ends with everyone safe all around—men on first and second and the run scored—and the guys in the dugout slapping their thighs, grinning big, and hooting at the sheer beauty of it.

more often than not, men seem isolated from one another

You know. Sweet!

The photographs here are images of ordinary men. Of men in isolation from one another, and upon reflection, men perhaps disconnected from what is best in themselves, not to mention everybody else. Nonetheless, the faces in many of the portraits radiate great warmth. As if in the act of taking these pictures, Arndt has discovered his relationship with these strangers, these brothers, and is passing it on to us. It's as if he's made their brotherly affection sparkle, as if each man were about to burst forth with a story and help us solve an intriguing puzzle. It could well be that Arndt's photographs also convey the common memory of men and something shared that cannot be denied or erased—good, bad, or indifferent.

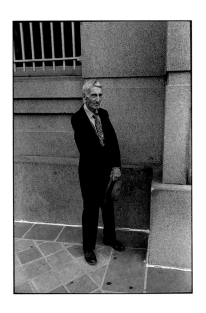
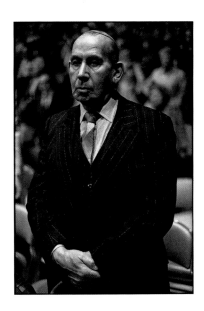
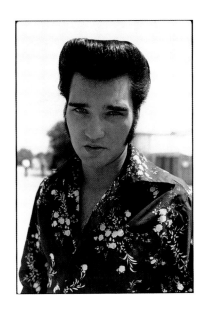
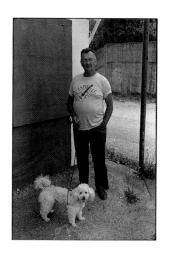
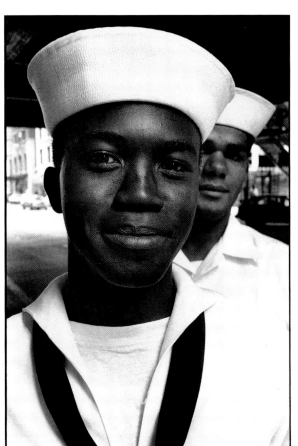
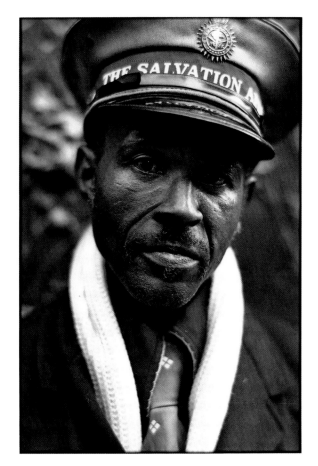
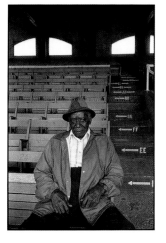
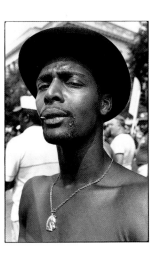

Men in America

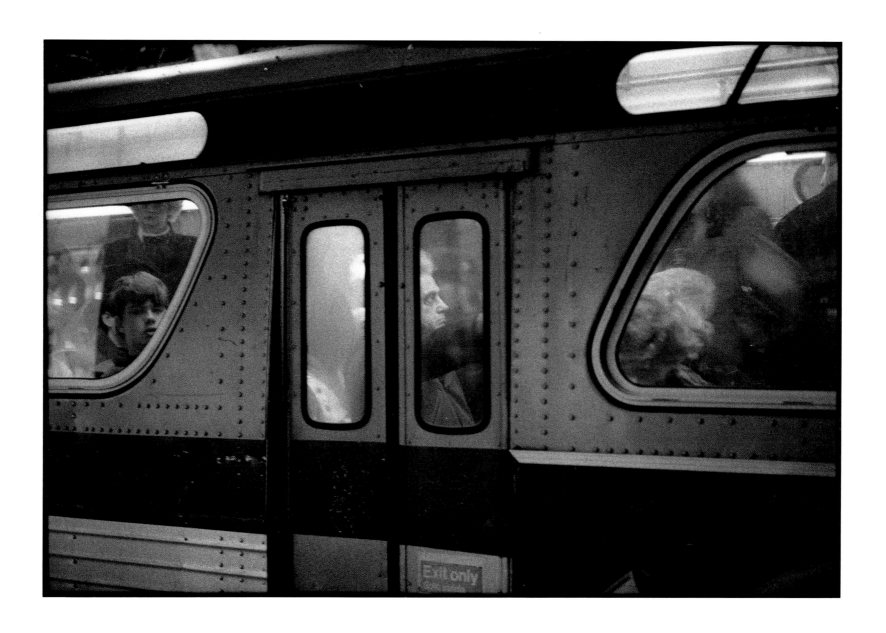

Man on a bus, Michigan Avenue, Chicago, 1989

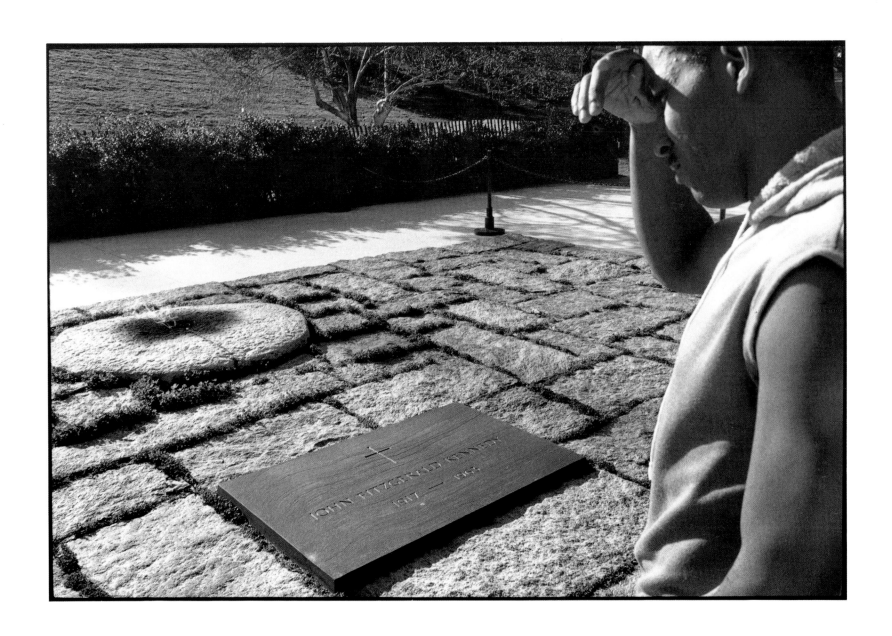

Grave site of John F. Kennedy, Arlington, Virginia, 1984

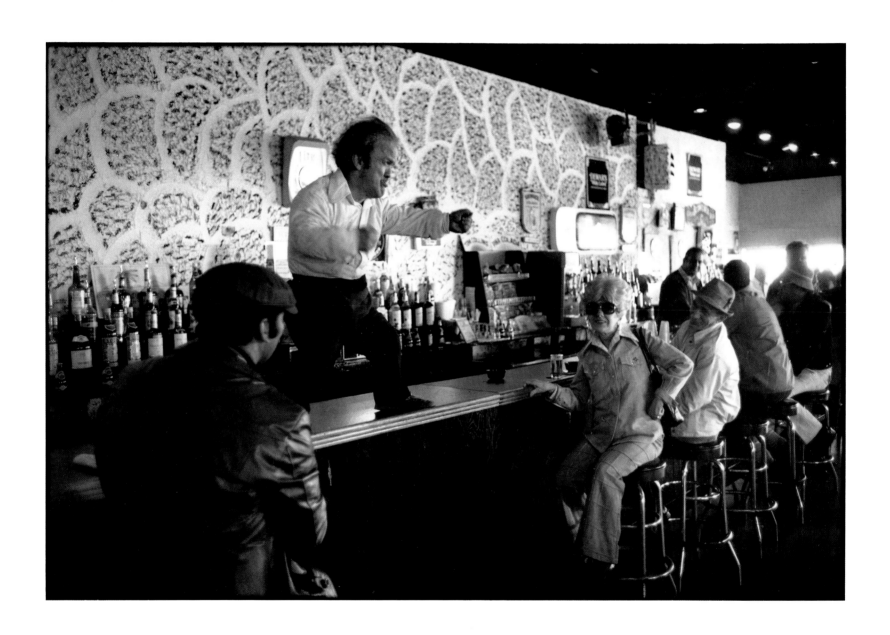

Man on Bar, Atlantis Bar, Coney Island, New York, 1980

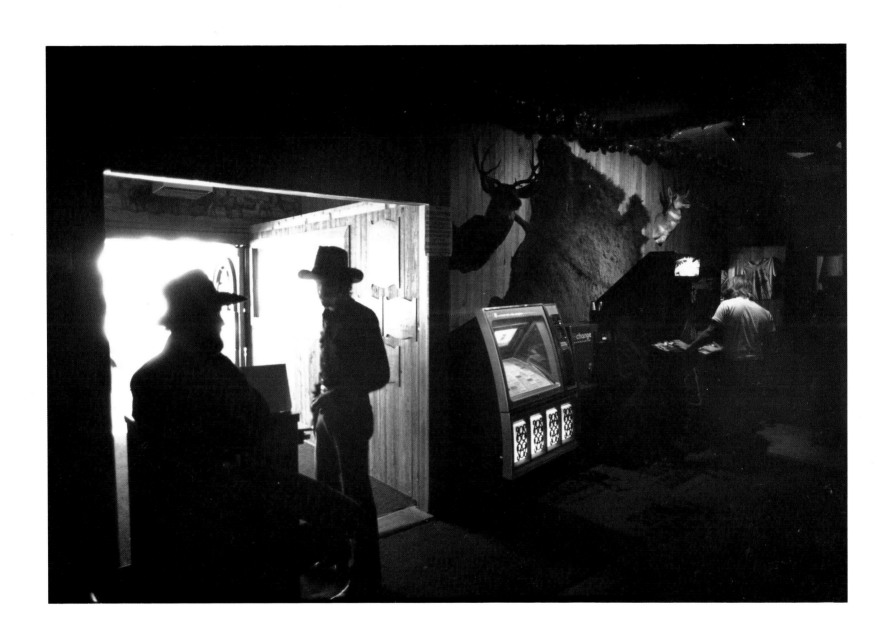

Cowboy Bar, Jackson Hole, Wyoming, 1981

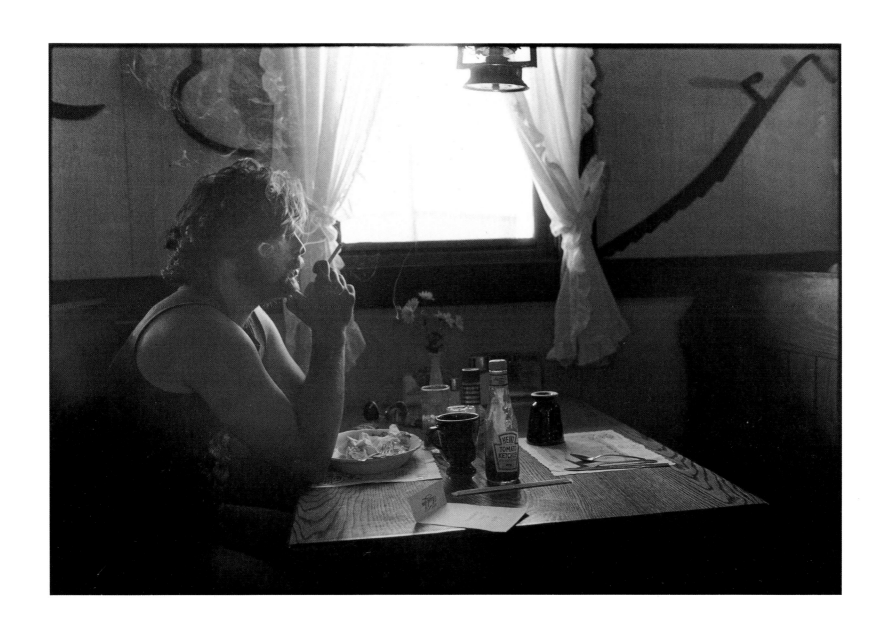

After Dinner cigarette, restaurant, Iowa, 1982

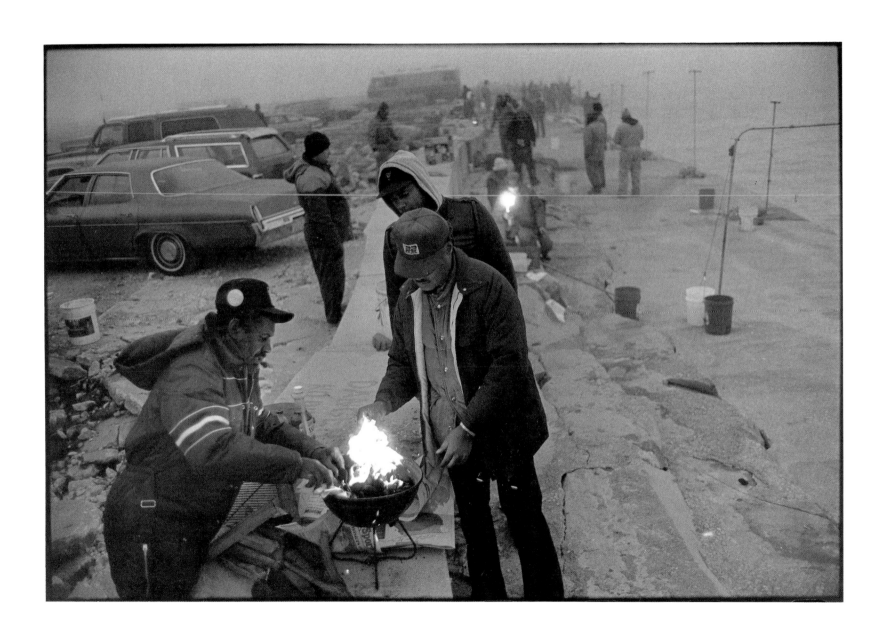

Smelt Fishing, South side of Chicago, Lake Michigan, 1986

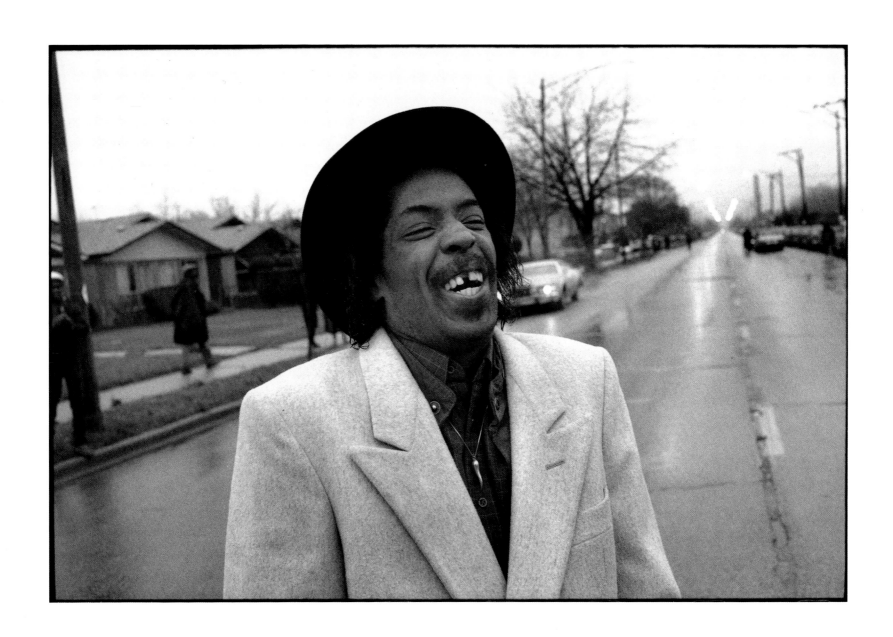

Man Laughing, Southside, Chicago, 1987

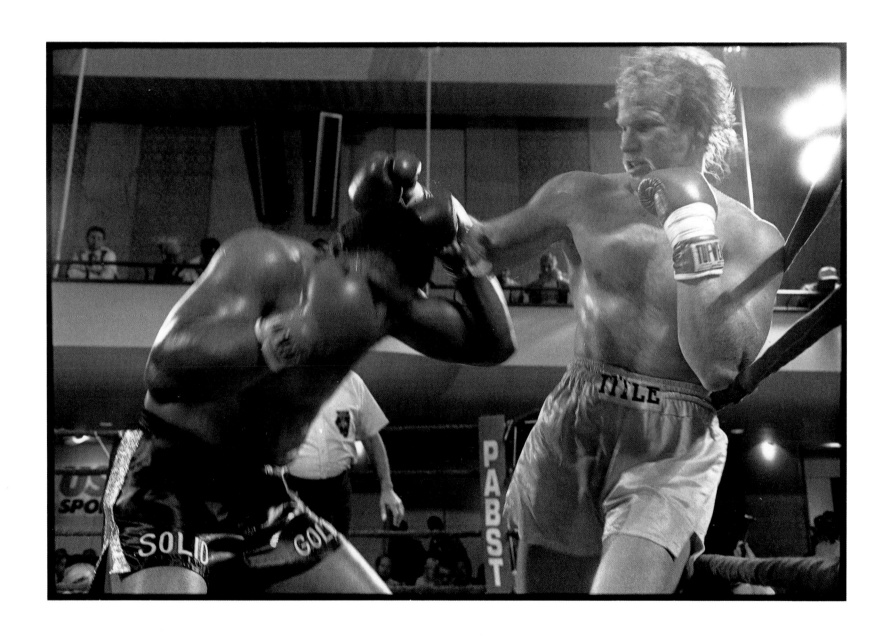

Boxing Match, Chicago, 1986

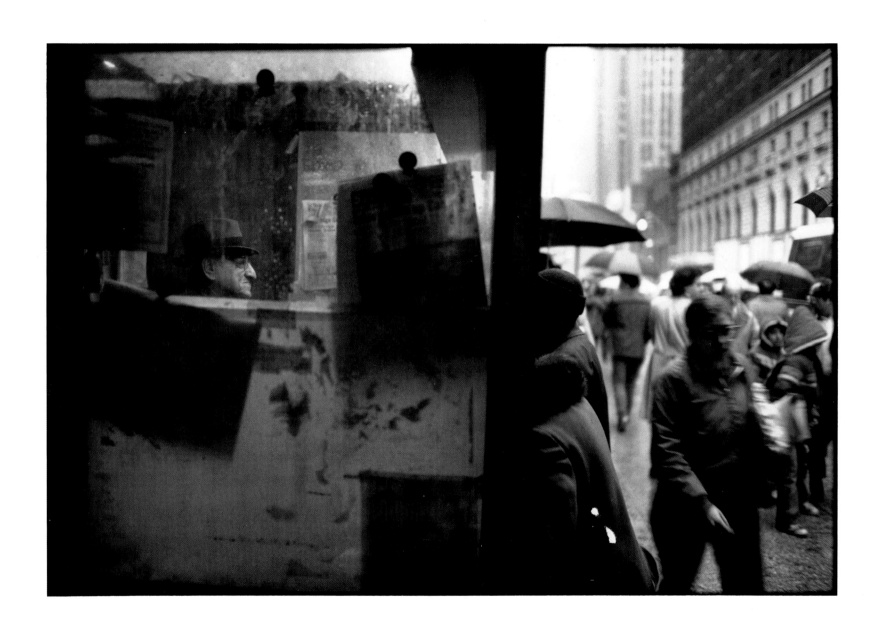

Newsstand outside Macy's, New York City, 1980

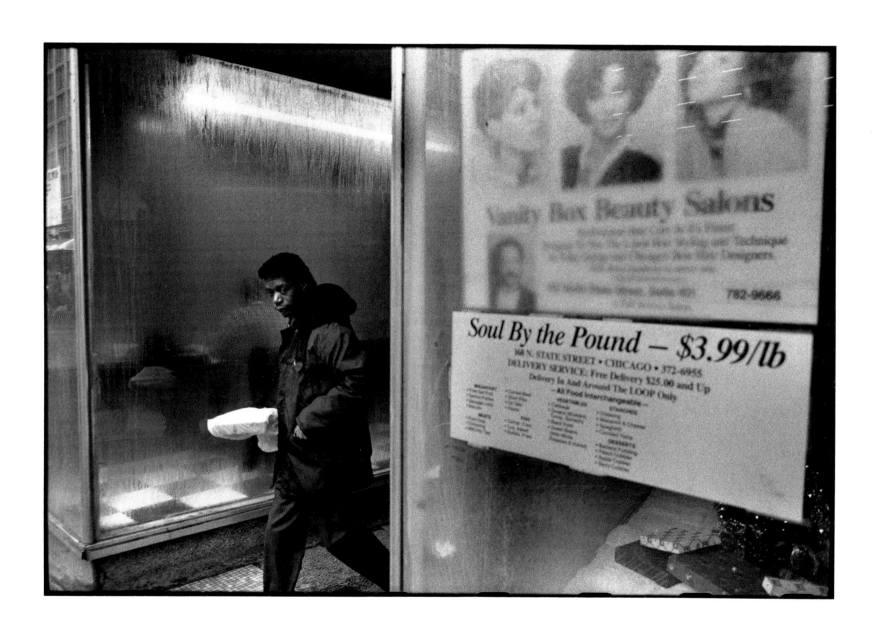

Soul by the pound, Chicago, 1990

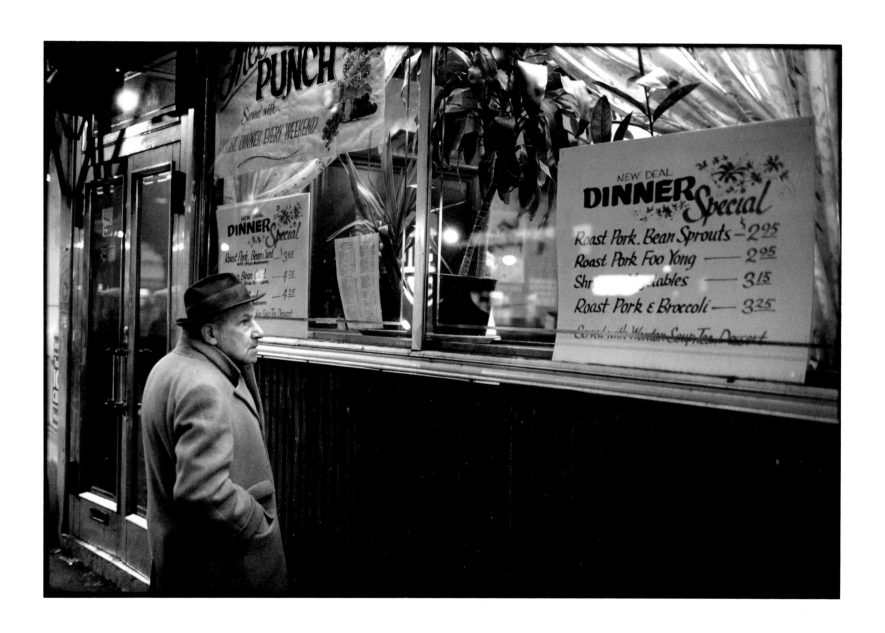

Reading the menu, Brighton Beach, New York, 1982

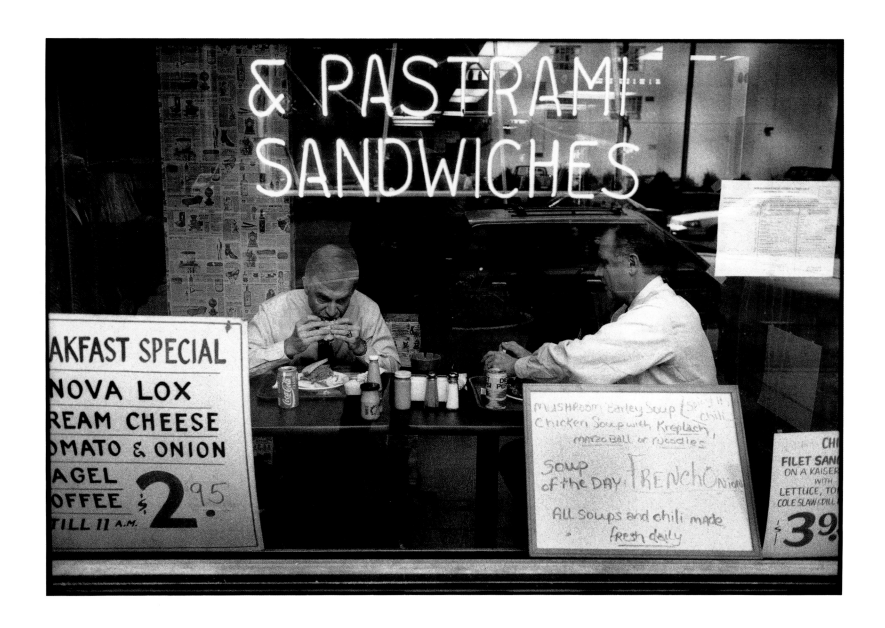

Restaurant, Chicago, 1989

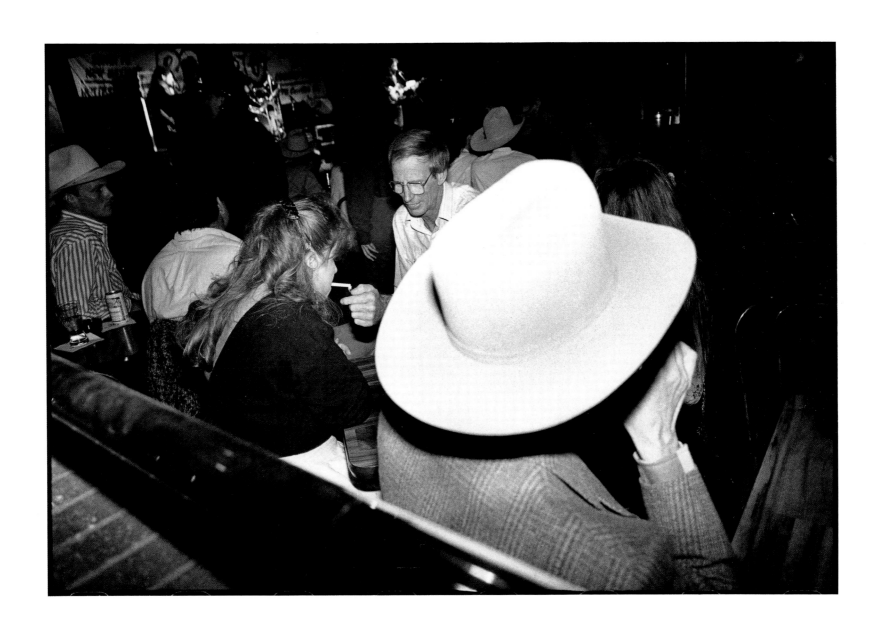

Bar scene, Sante Fe, New Mexico, 1990

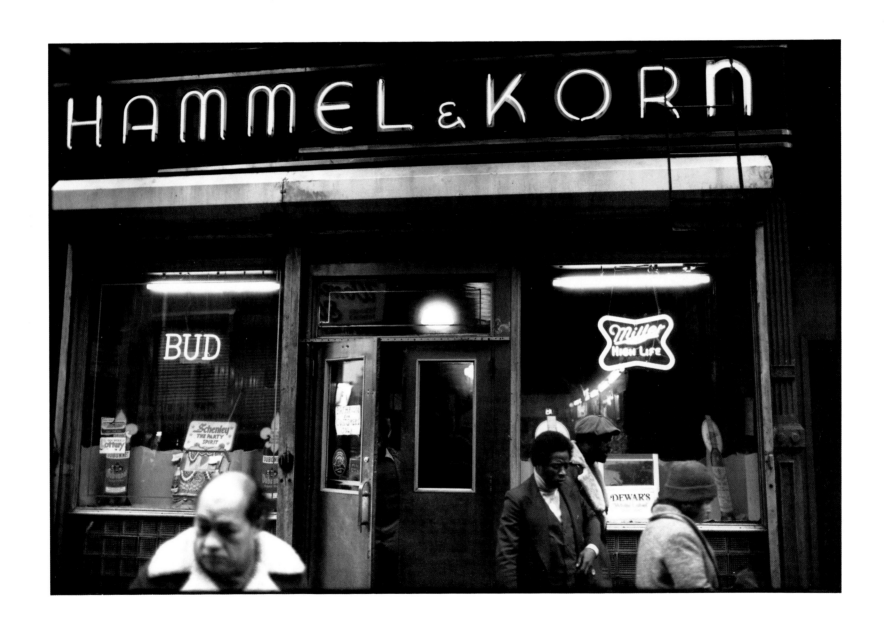

Men leaving bar, Lower East Side, New York, 1980

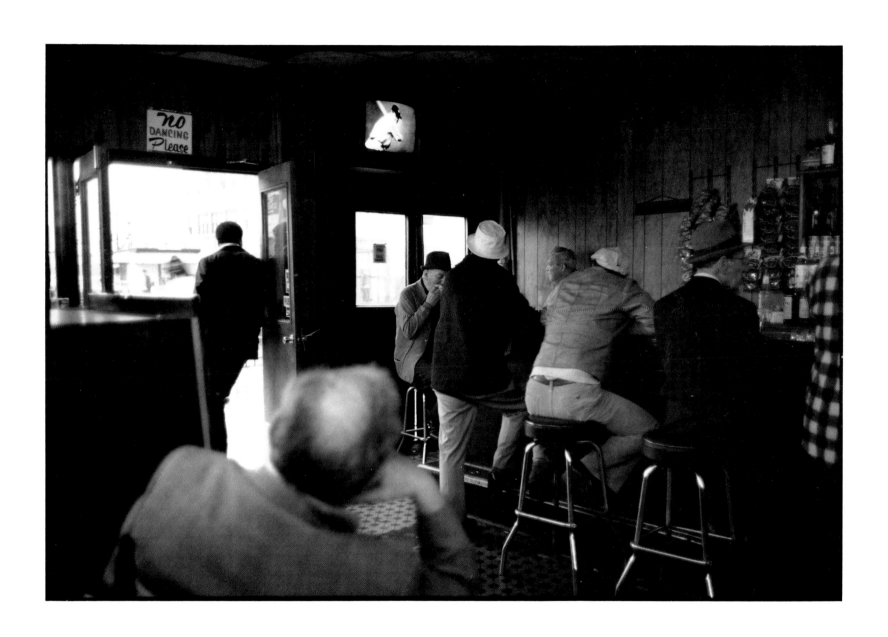

Men watching TV, Pellone's bar, Coney Island, New York, 1979

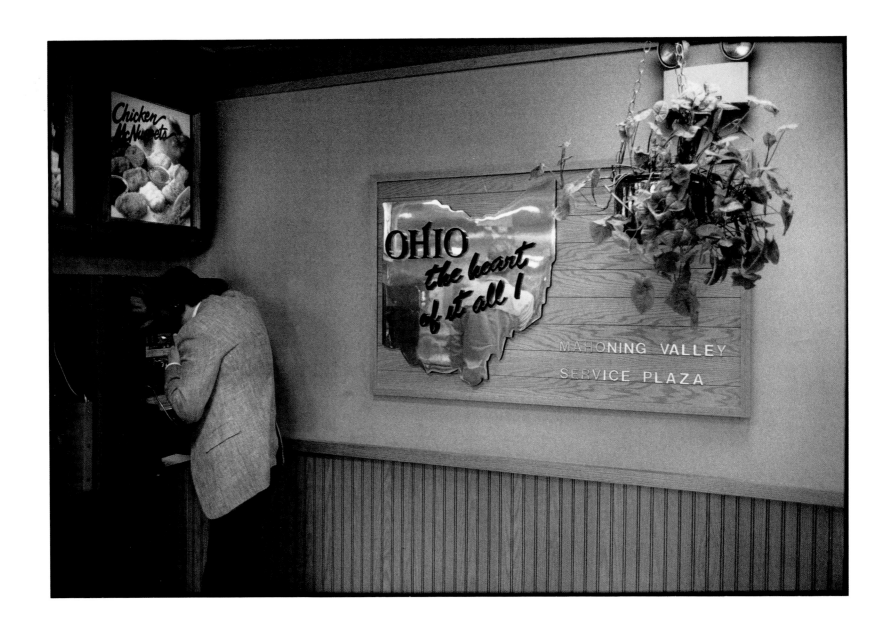

Truckstop, Ohio, 1990

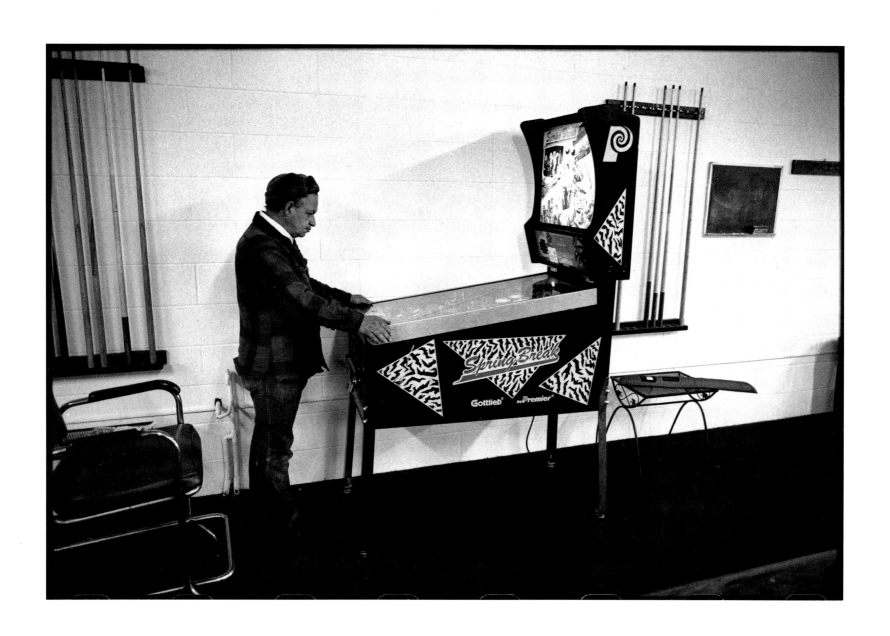

Playing a pinball machine, pool hall, Sante Fe, New Mexico, 1990

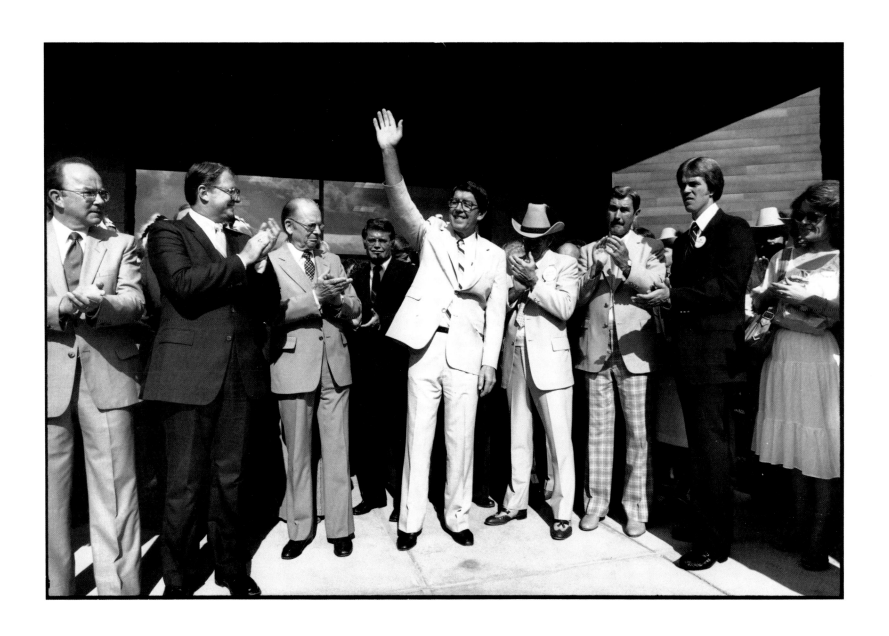

Governor of Idaho opening a shopping center, Pocatello, Idaho, 1981

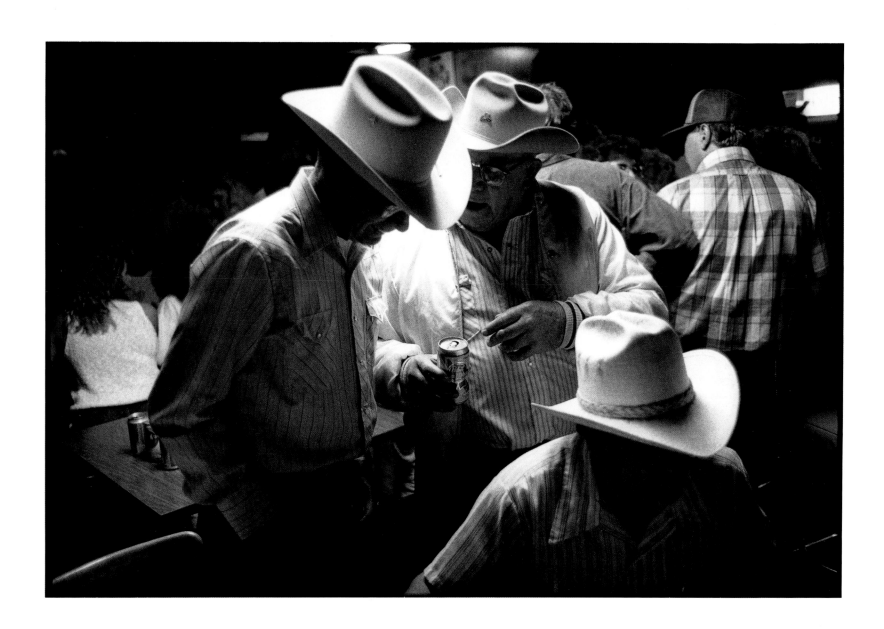

Men in a bar, Hazelton, North Dakota, 1989

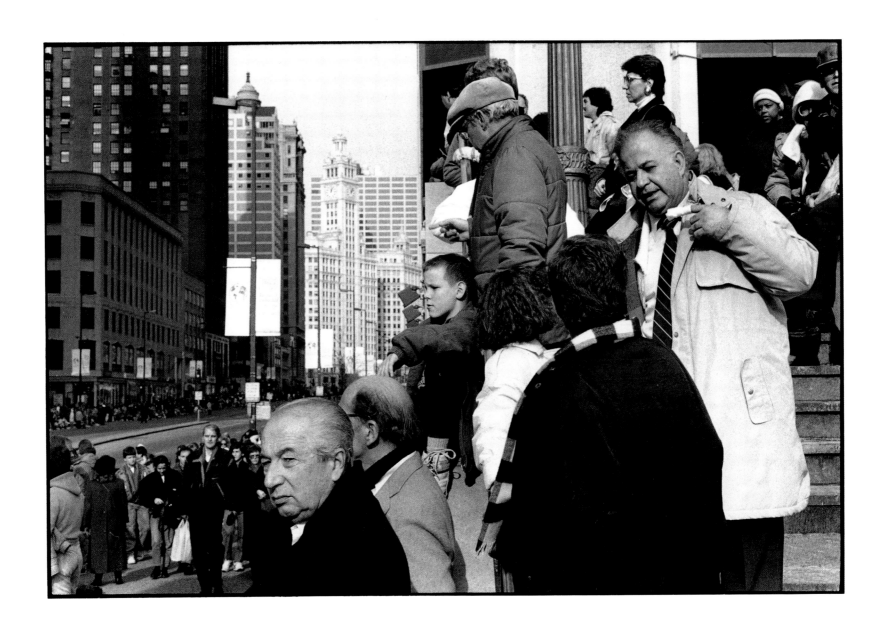

Men watching a parade, Chicago, 1990

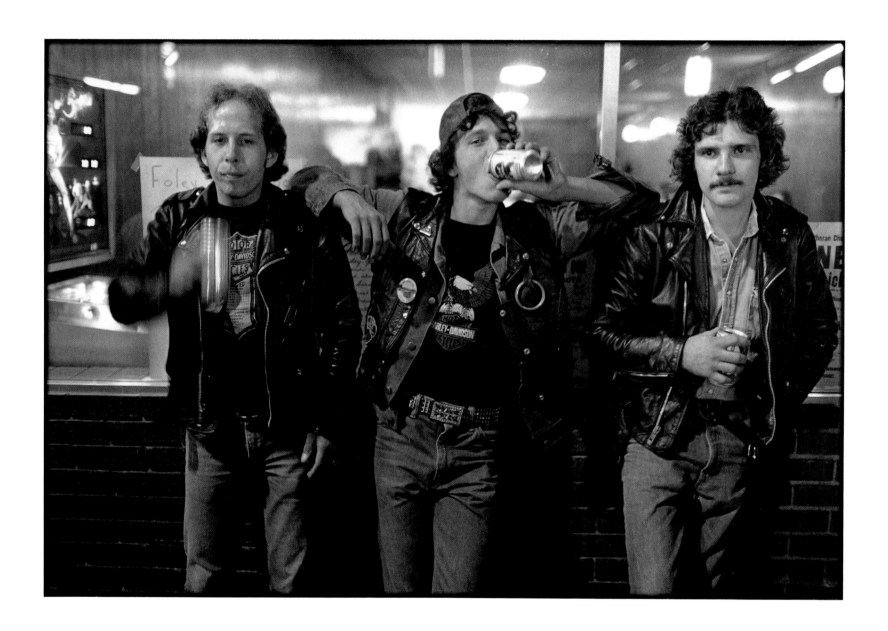

Young men drinking beer, Foley, Minnesota, 1981

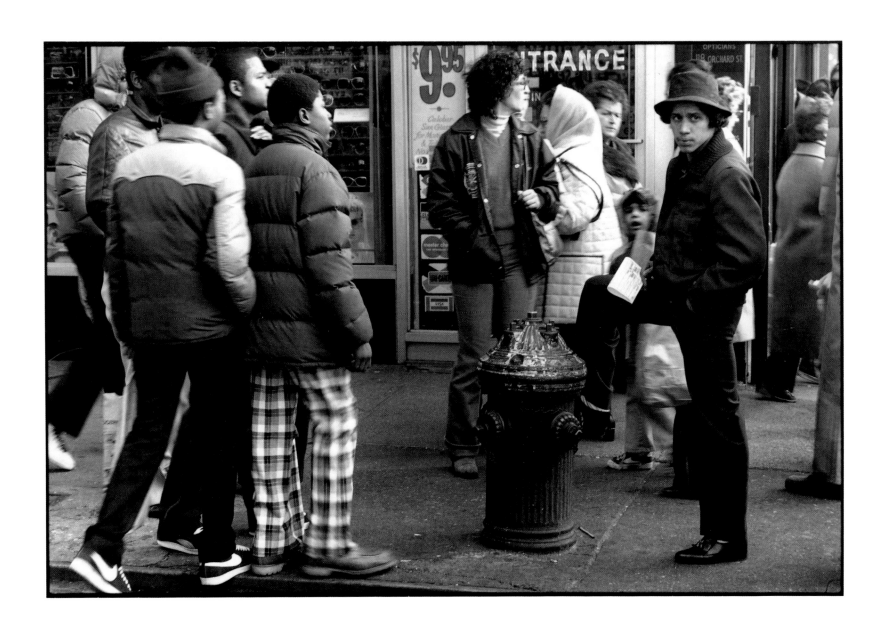

Orchard Street, Lower East Side, New York City, 1980

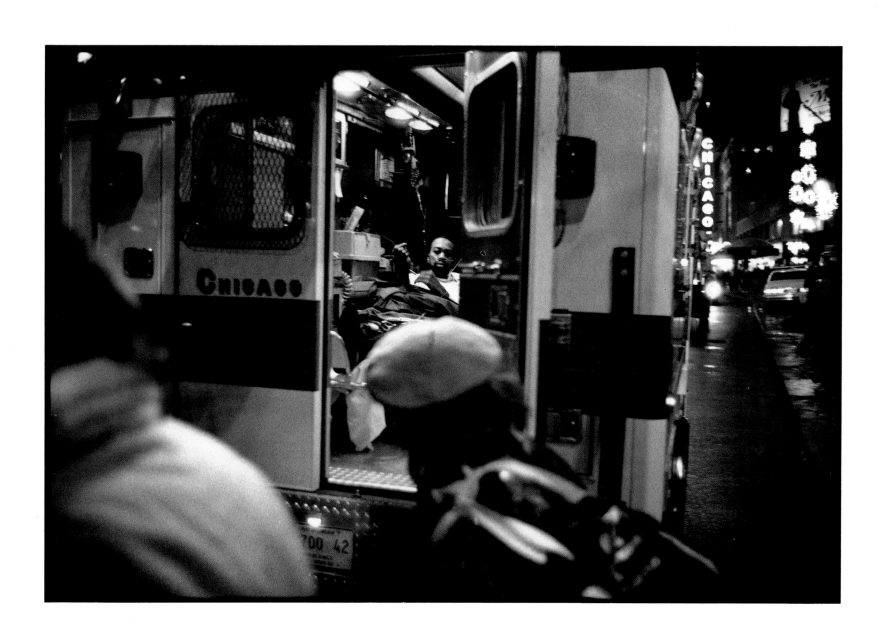

Man in ambulance, State Street, Chicago, 1986

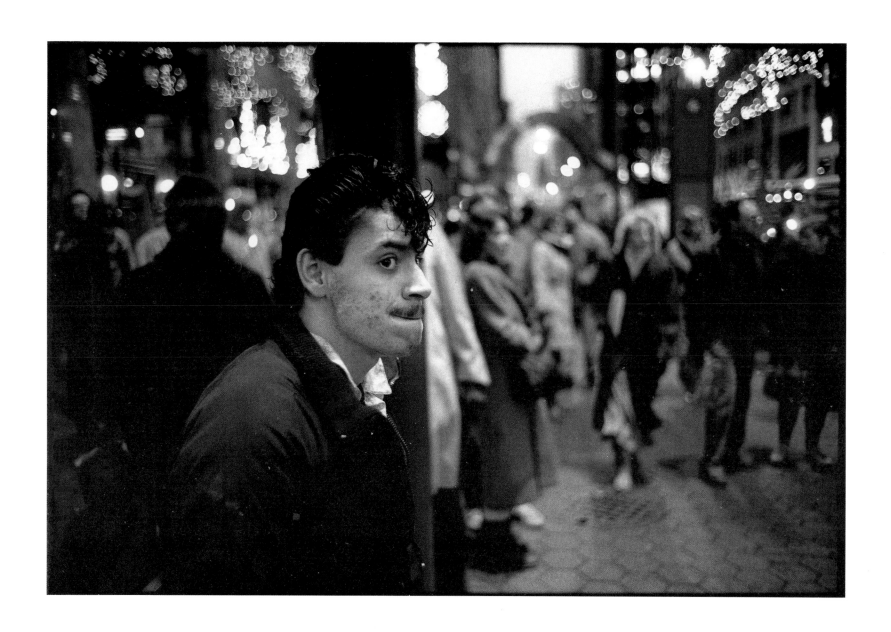

Man standing on State Street, Chicago, 1986

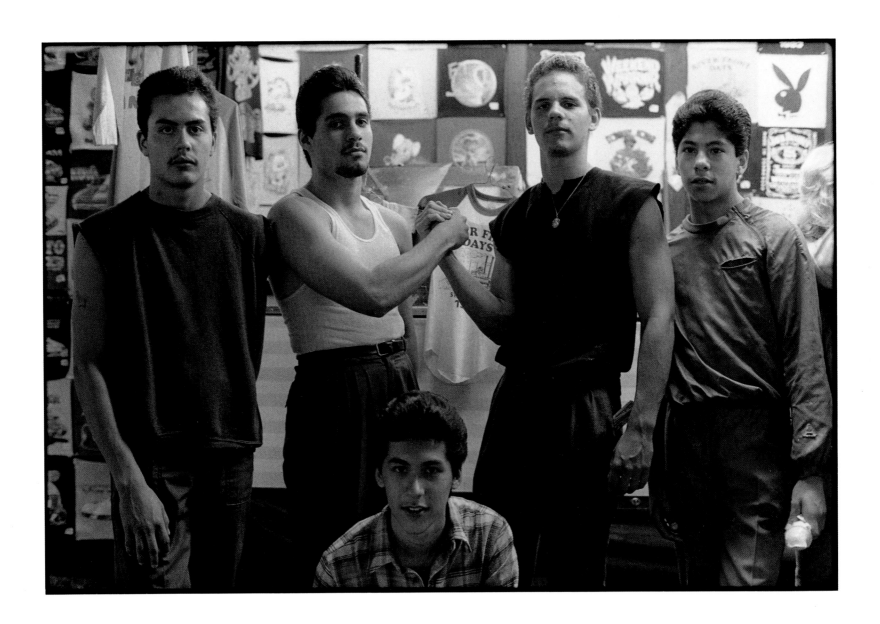

Young men, River Front Days*, St. Paul, Minnesota, 1983*

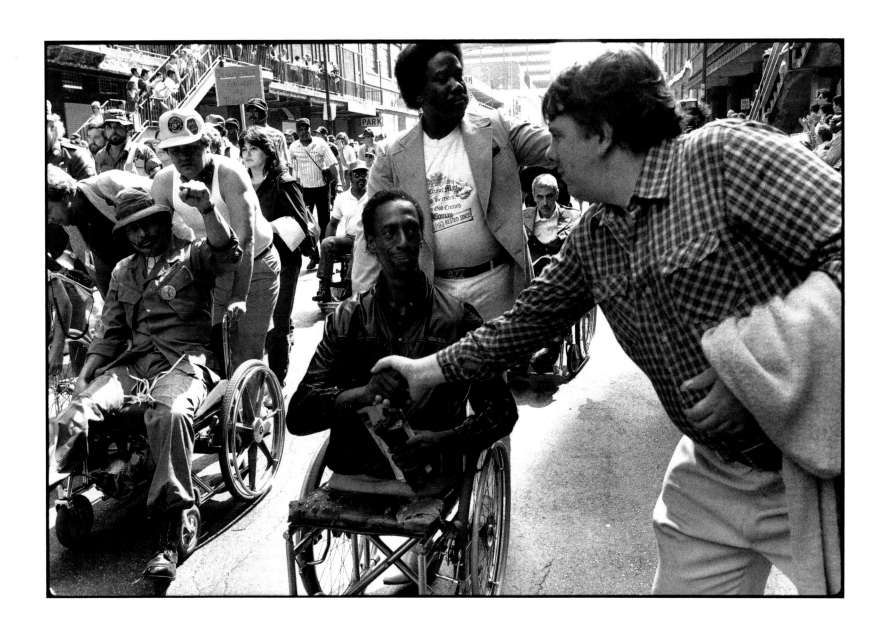

Vietnam Veterans' Day parade, Chicago, 1986

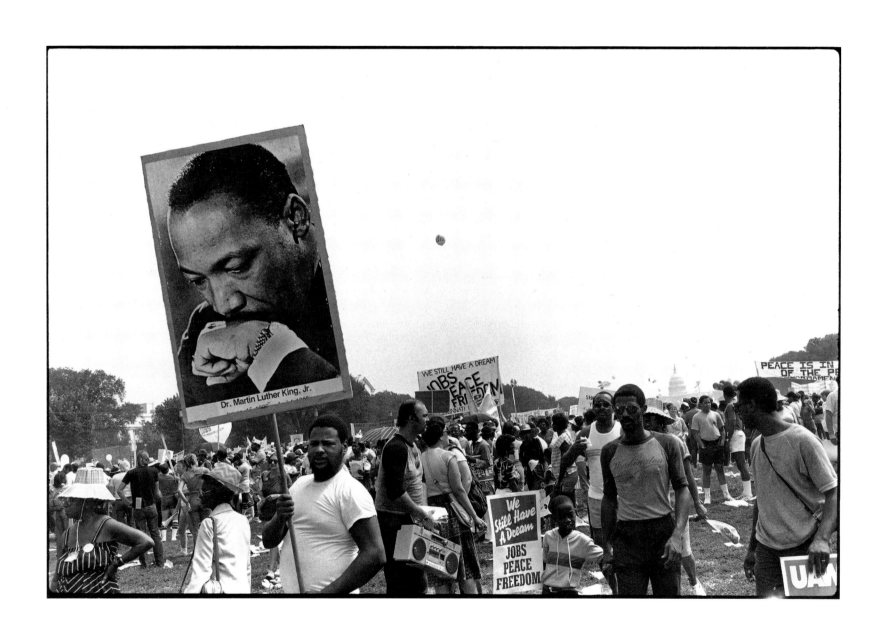

Twentieth Anniversary, Martin Luther King Rally, Washington, D.C., 1983

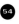

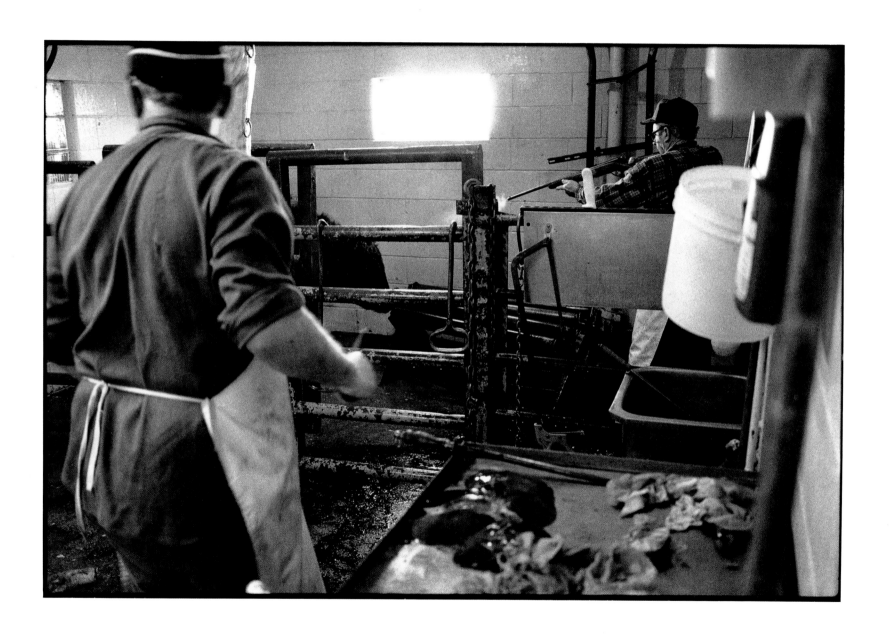

Man shooting cow, Sleepy Eye, Minnesota, 1985

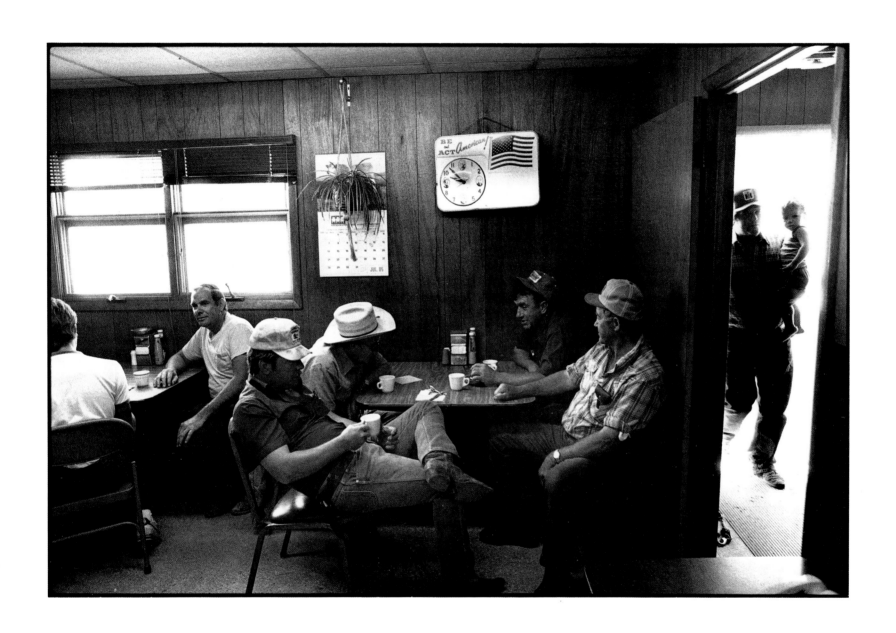

Coffeeshop, Auction Barn, Sleepy Eye, Minnesota, 1985

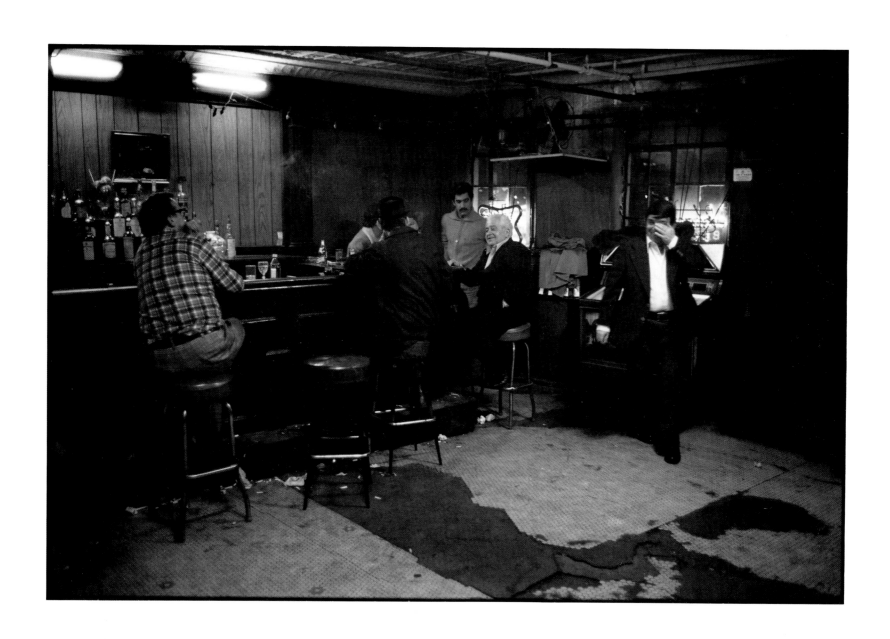

Men in a bar, Lower East Side, New York City, 1980

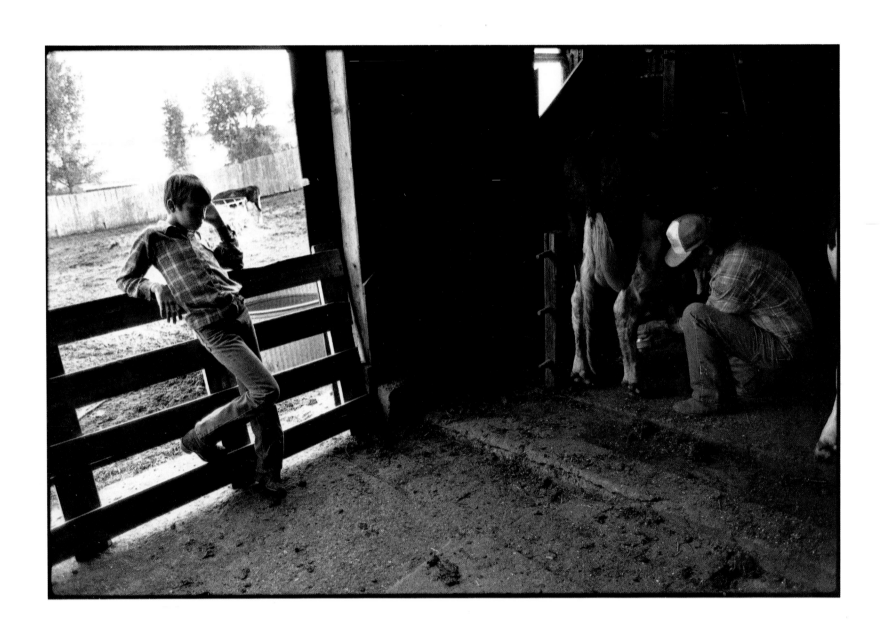

Joe Shea milking a cow with his son Jim, Hazelton, North Dakota, 1985

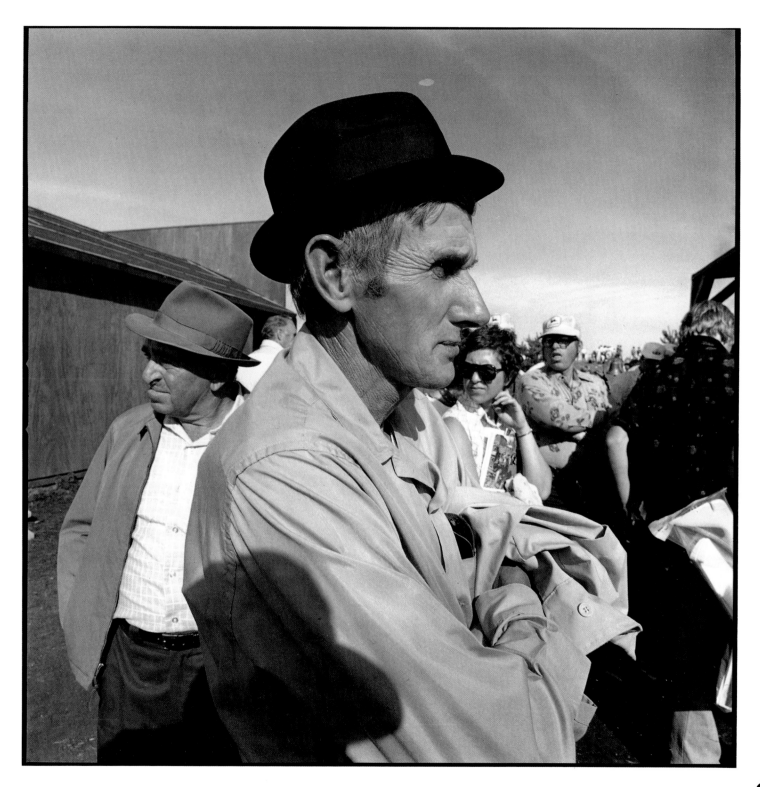

Farmer, Crystal Lake, Minnesota, 1976

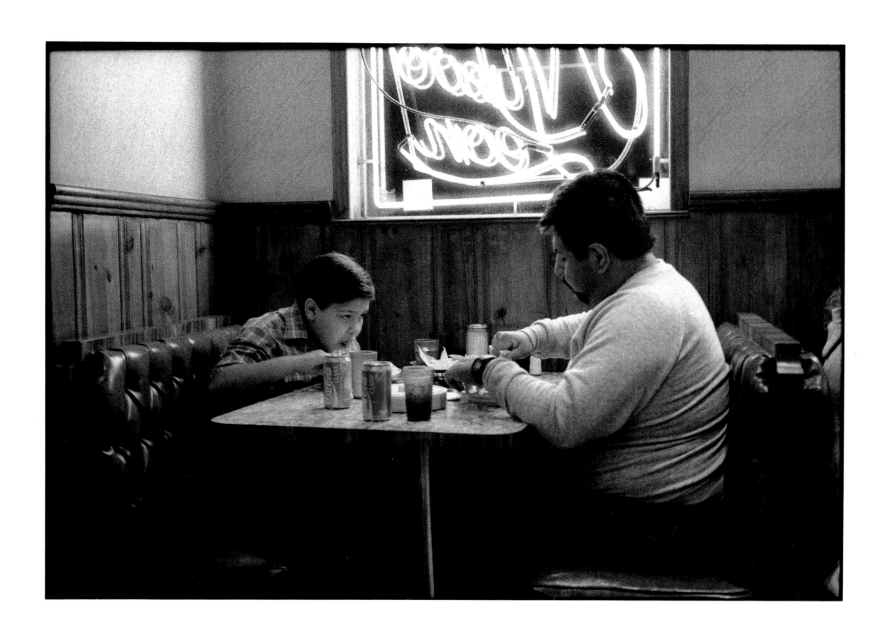

Father and son eating in Nuevo Leon restaurant, Chicago, 1989

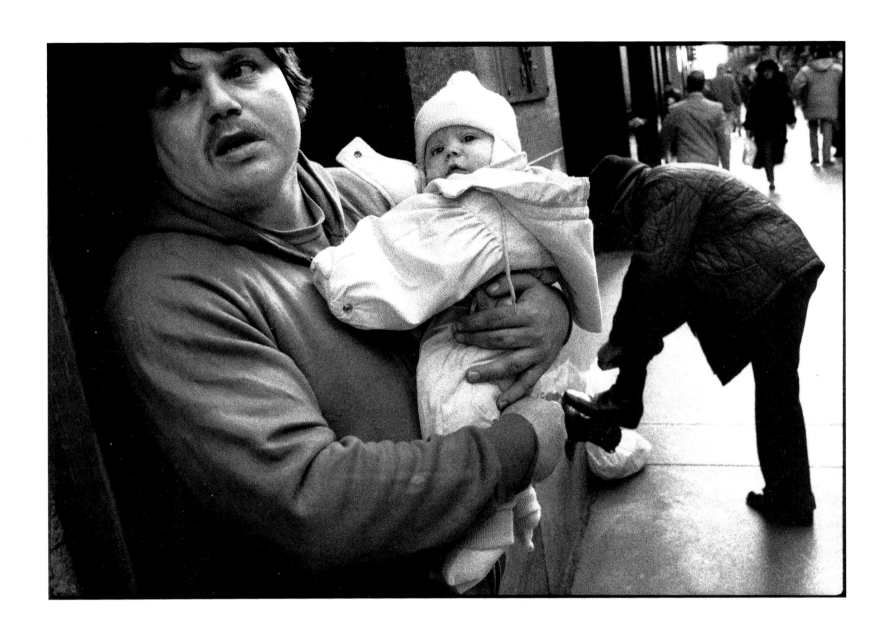

Man holding his son, Wabash Street, Chicago, 1990

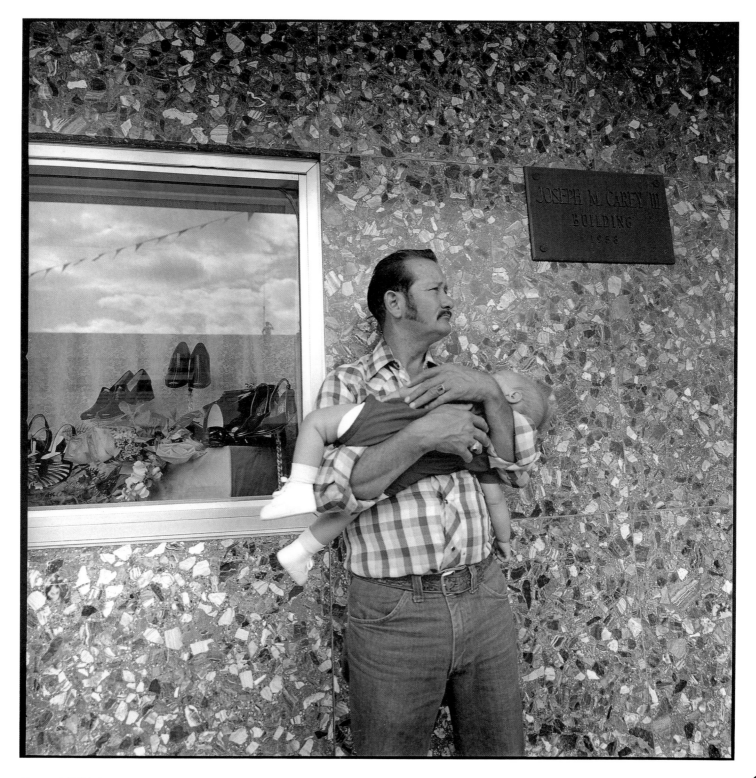

Man and Child, Cheyenne, Wyoming, 1975

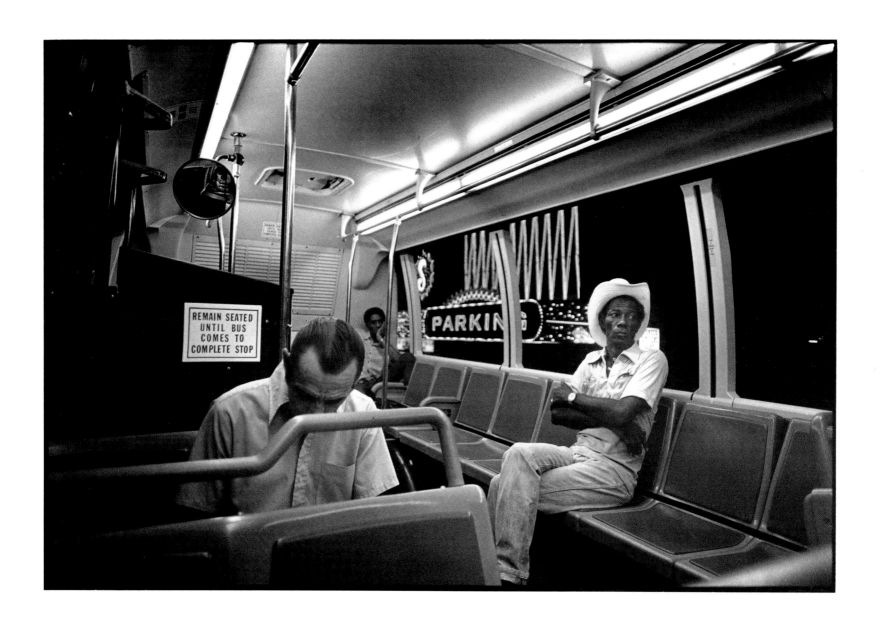

Men riding bus, Las Vegas, 1981

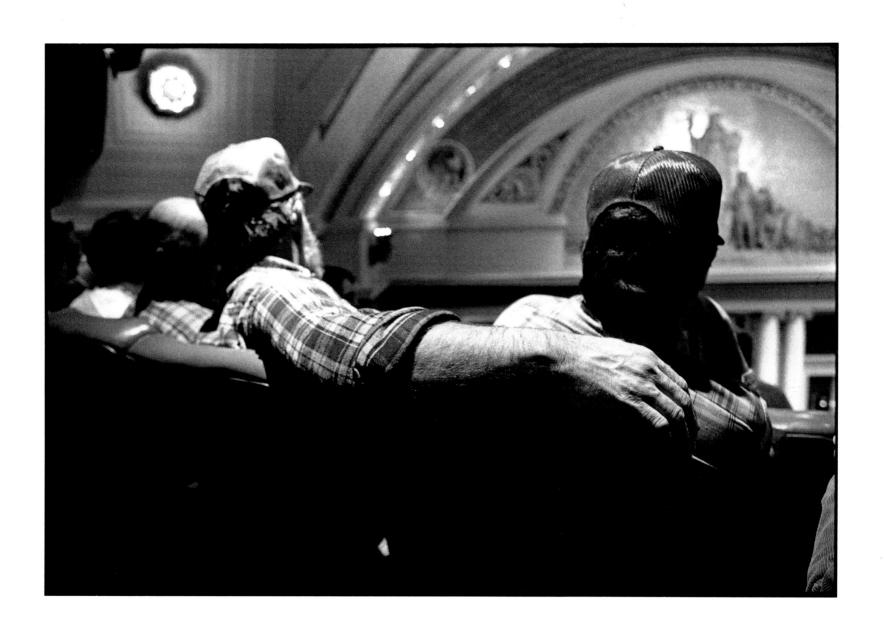

Farmers listening to a debate on farm foreclosures, State Capital, St. Paul, Minnesota, 1985

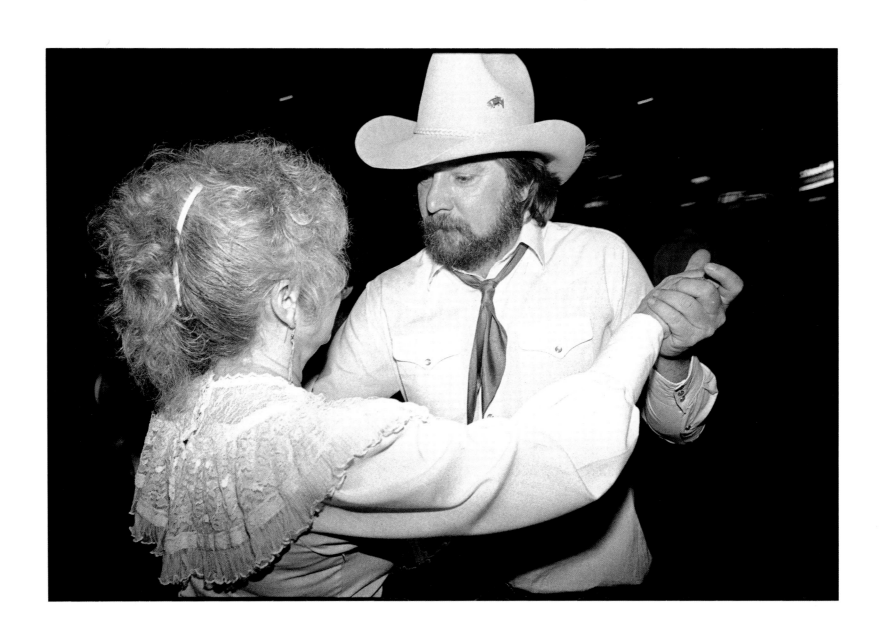

Couple dancing, dance hall, Sante Fe, New Mexico, 1990

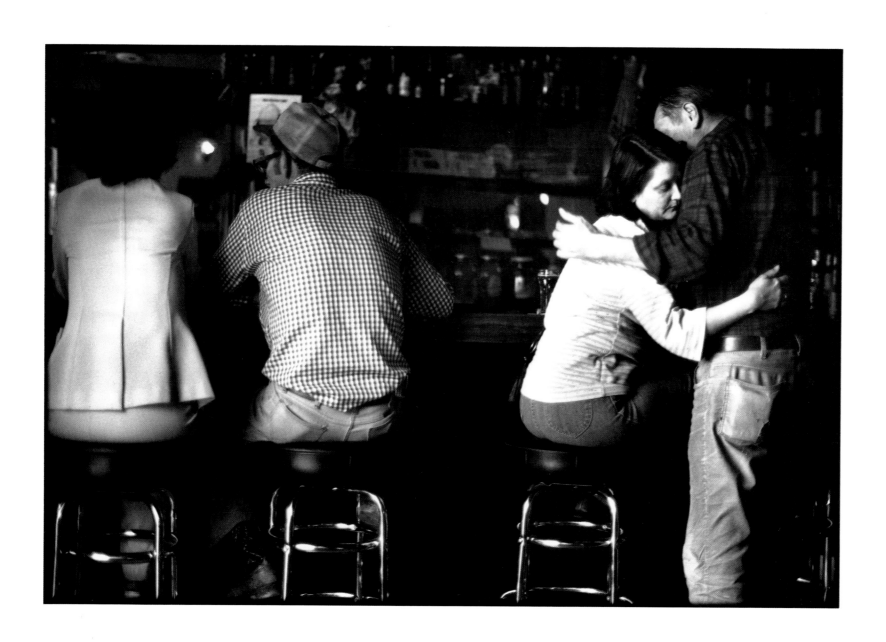

Two couples in a bar, Idaho Falls, Idaho, 1981

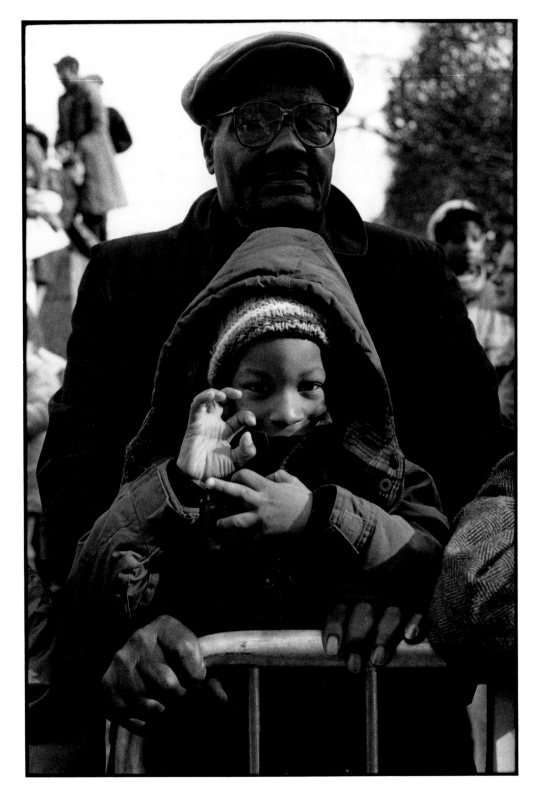

Watching a parade, Chicago, 1989

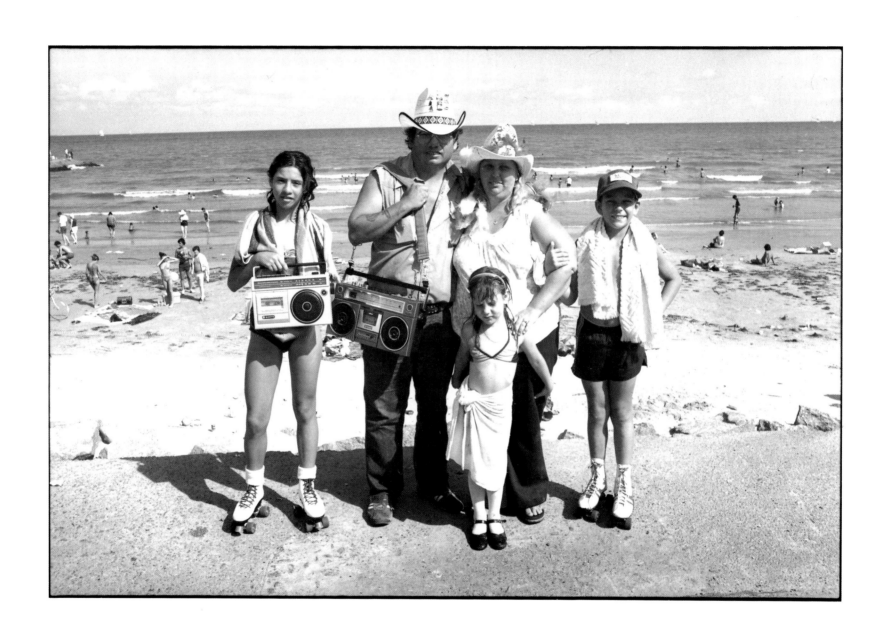

Family on the beach, Galveston, Texas, 1982

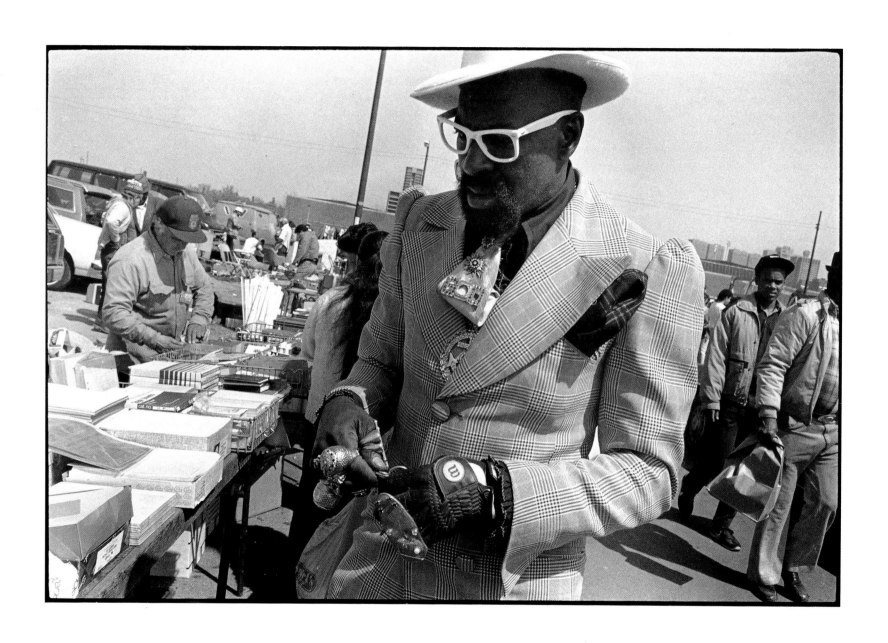

Shopping, Maxwell Street, Chicago, 1987

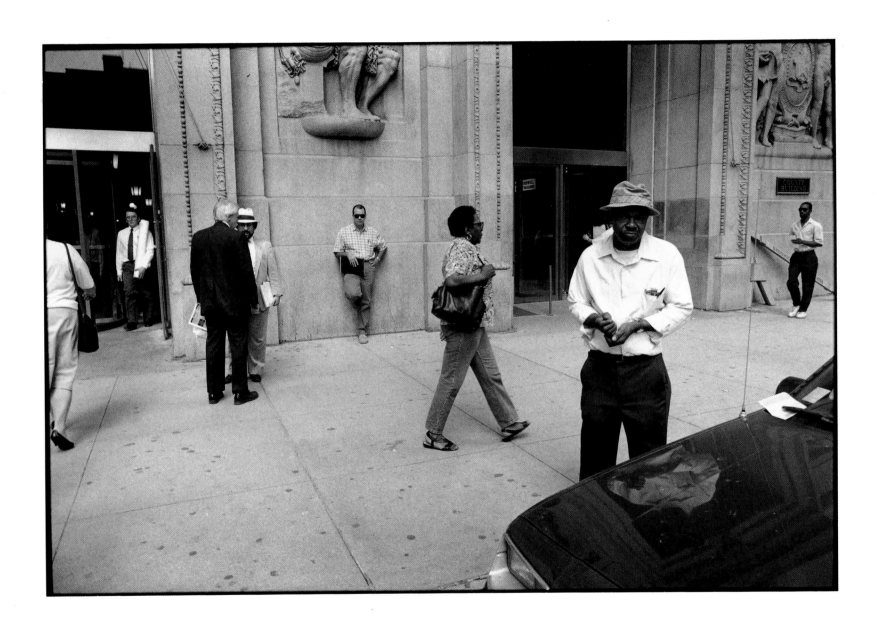

Outside City Hall, Chicago, 1990

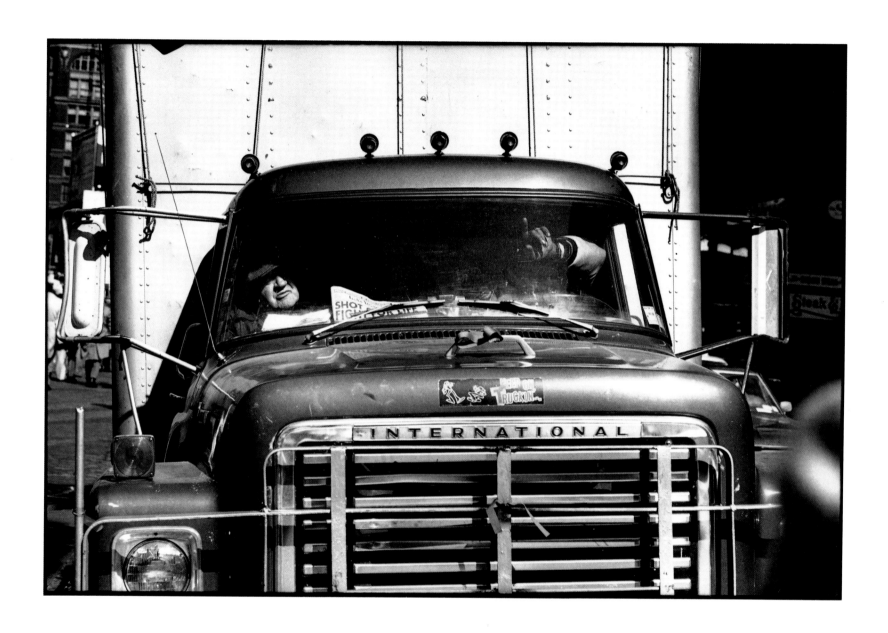

Men in a truck, New York City, 1981

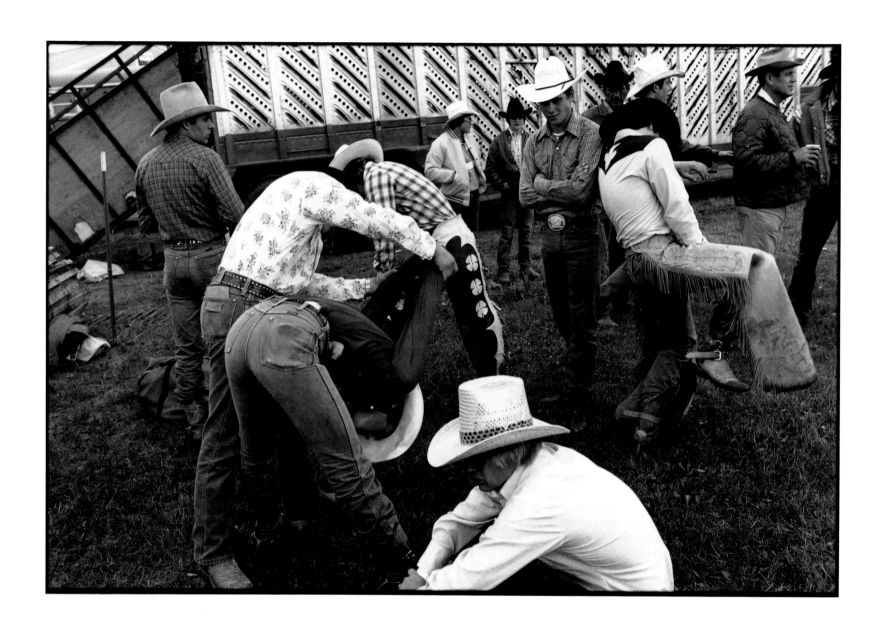

Cowboy's rodeo, Mora, Minnesota, 1982

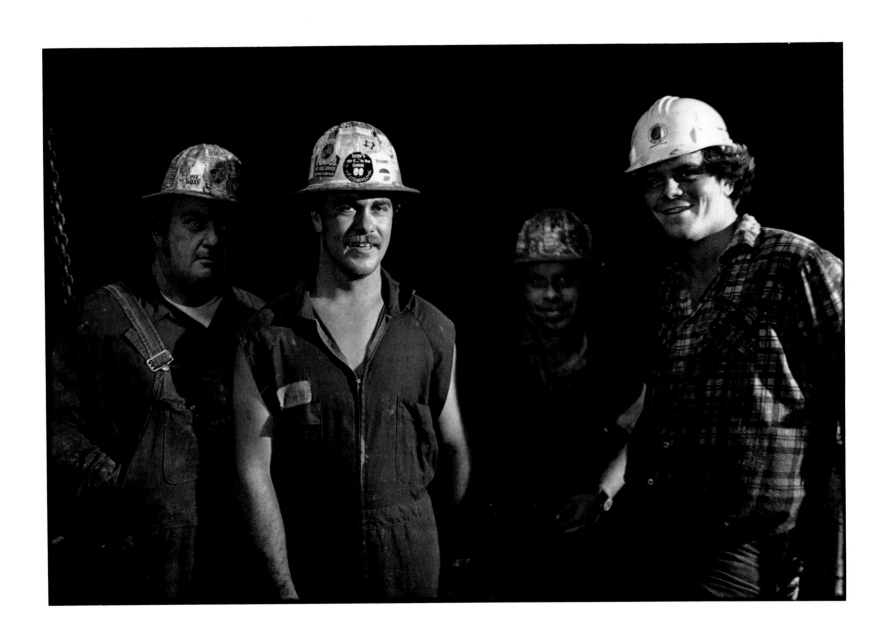

Roughnecks, oil rig nightshift, El Campo, Texas, 1982

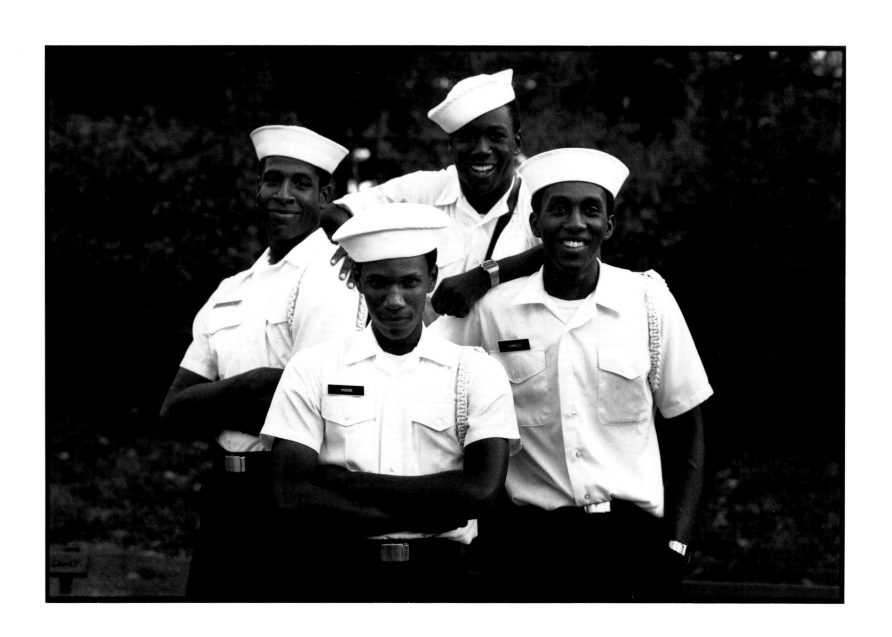

Four Coast Guard cadets, Great America, Illinois, 1981

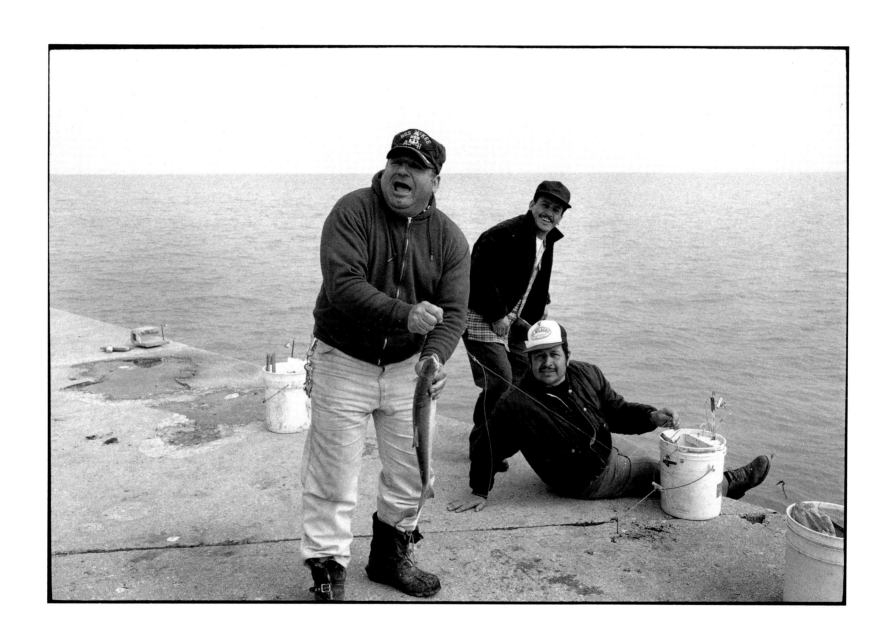

Men fishing, Lake Michigan, Chicago, 1987

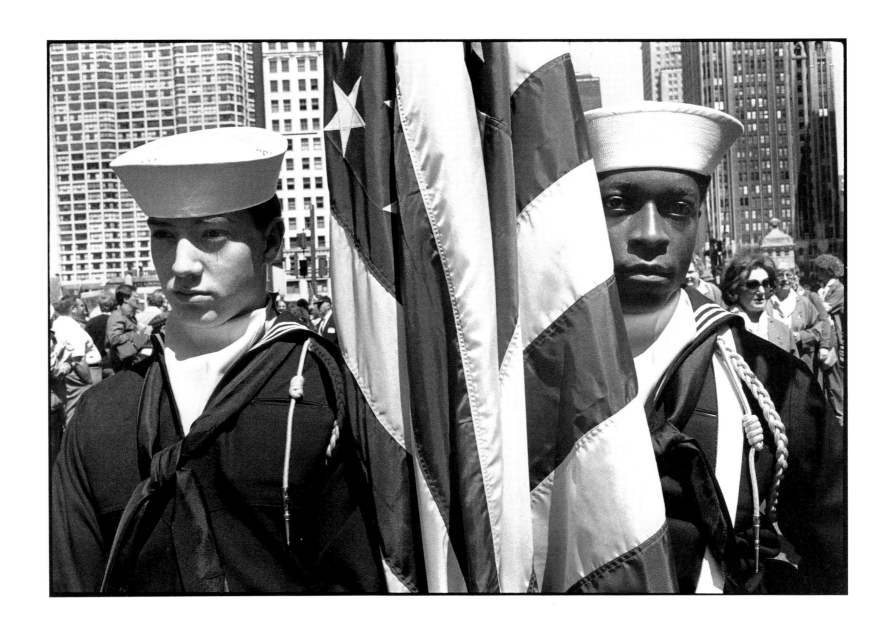

Honorguard Parade, Chicago, 1987

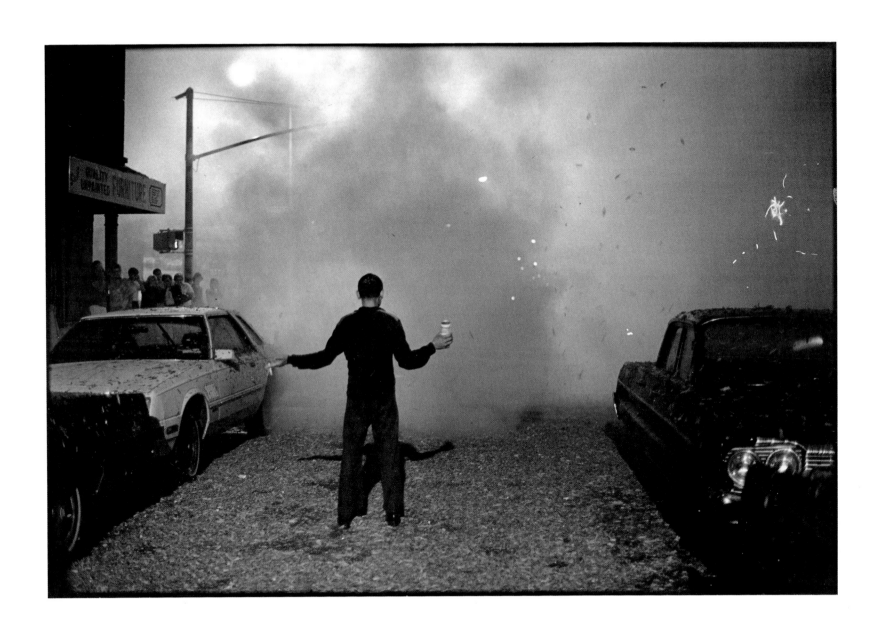

Fourth of July, Little Italy, New York City, 1981

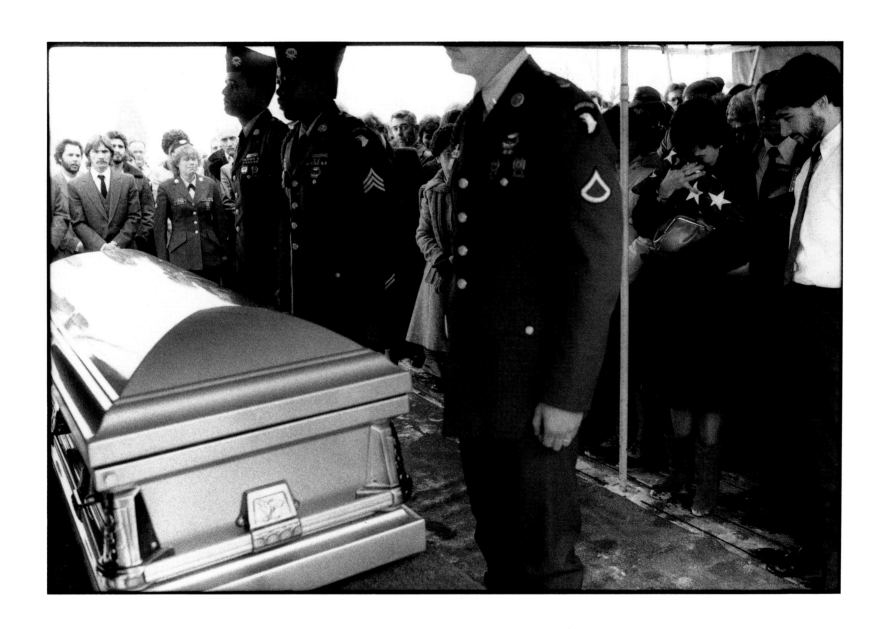

Funeral of Staff Sergeant Mark Kubic, member of the Screaming Eagles, Fort Snelling Cemetary, Minneapolis, Minnesota, January 3, 1986

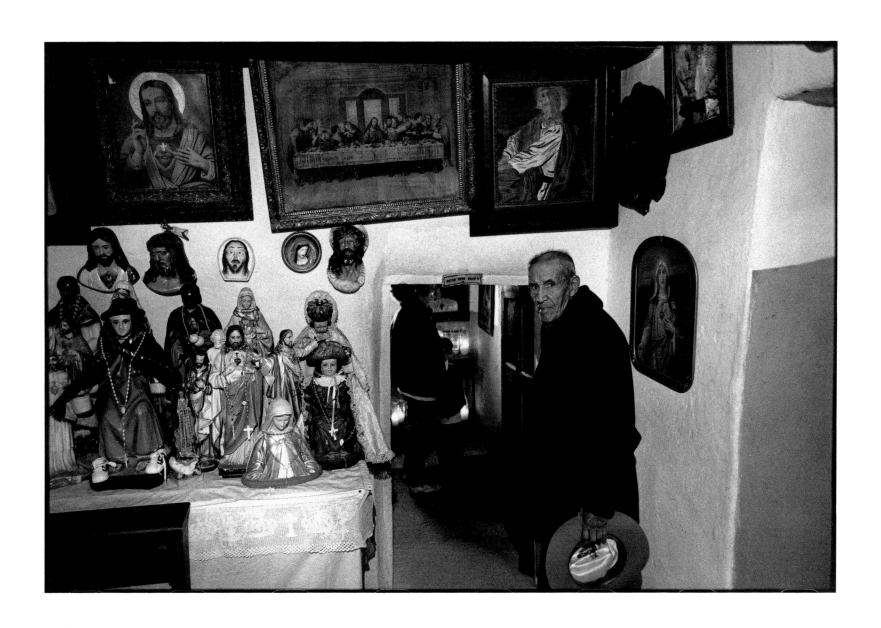

Man in Spanish mission near Taos, New Mexico

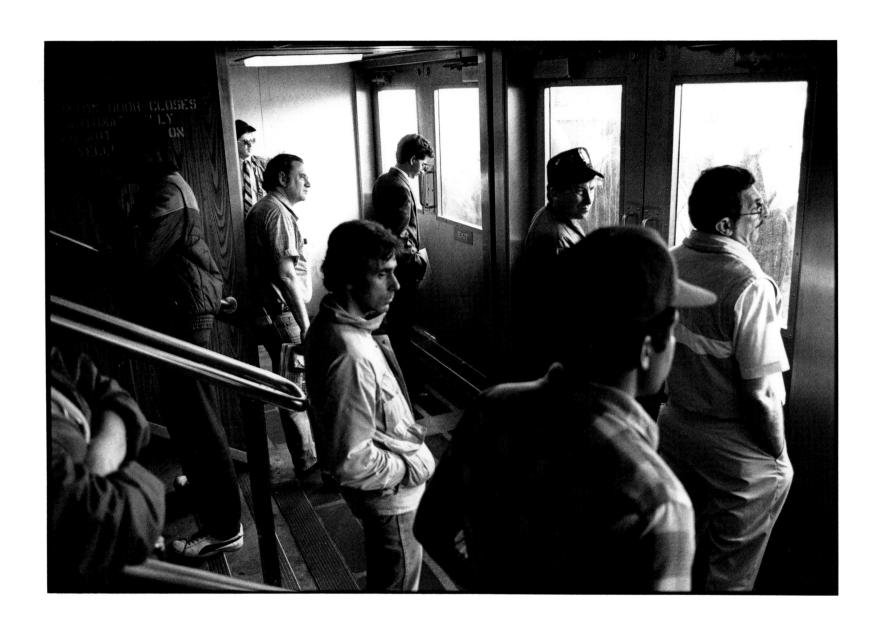

Staten Island ferry, New York City, 1986

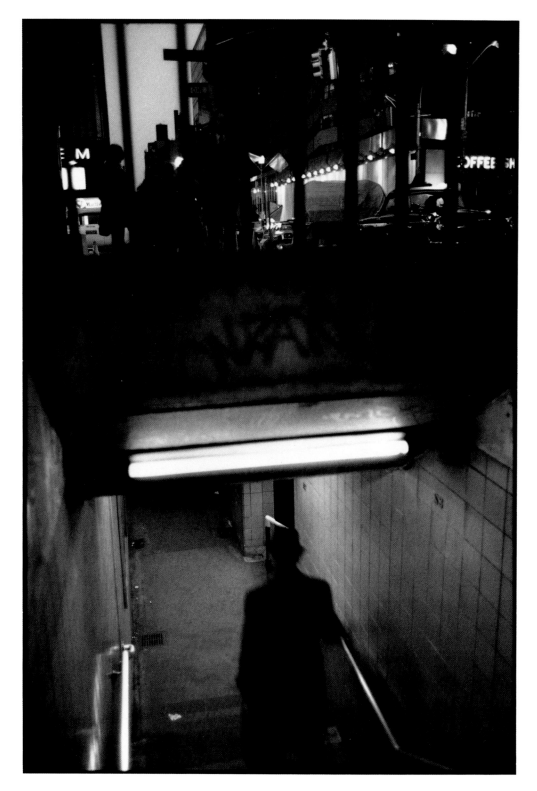

Entering subway, New York City, 1979

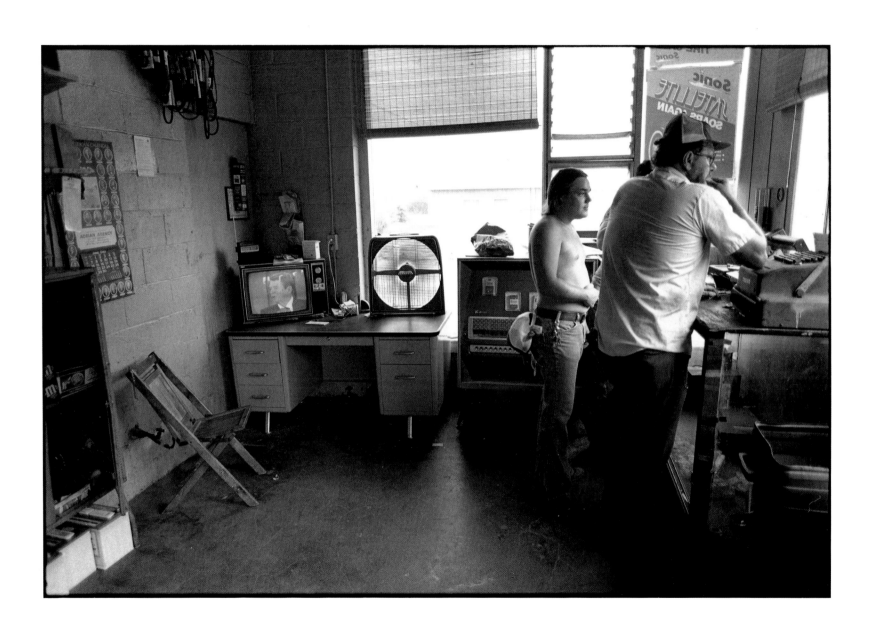

Men listening to press conference, gas station, Missouri, 1982

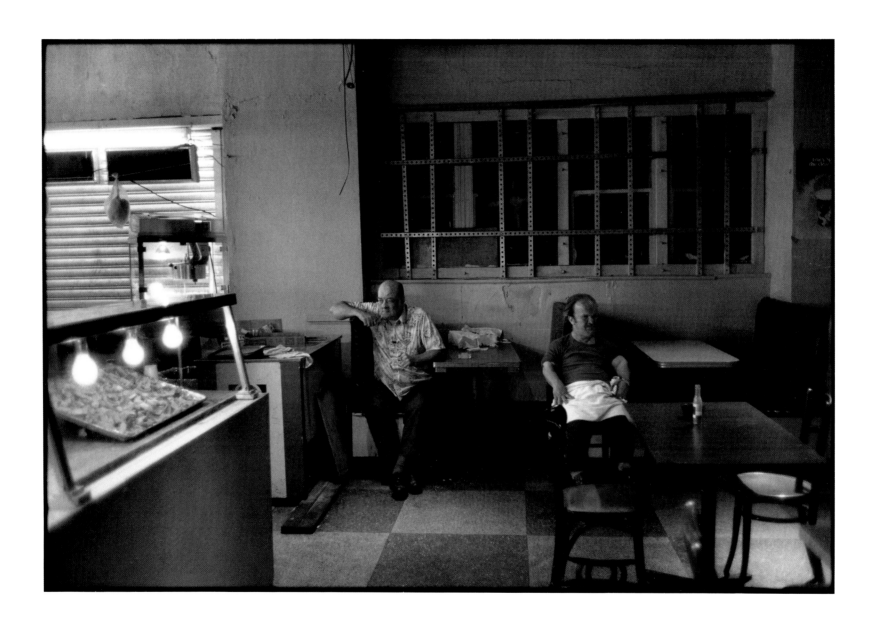

Coney Island, New York, 1981

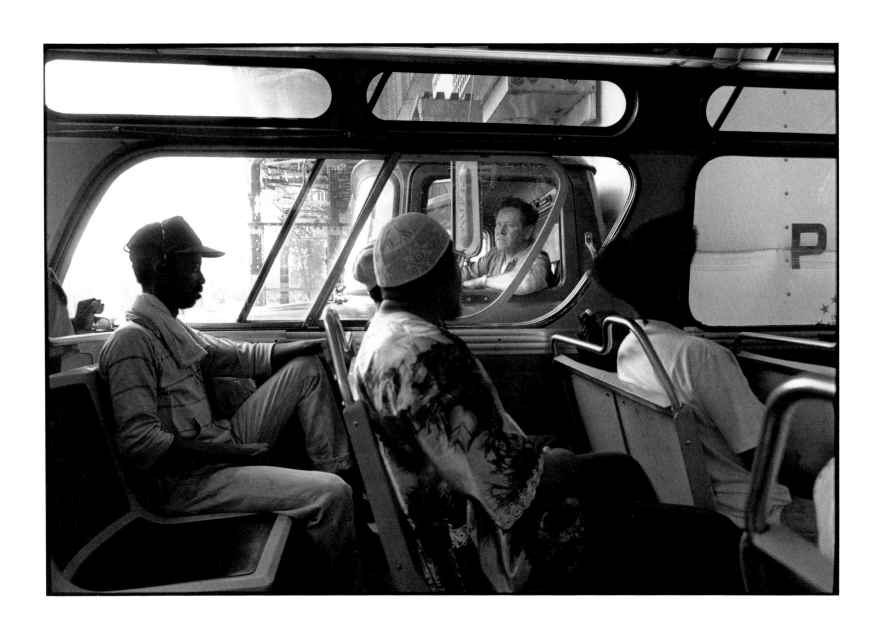

Bus passing truck driver, 57th Street, Chicago, 1990

Biography

Thomas Frederick Arndt was born in Minneapolis, Minnesota in 1944, and has lived there most of his life. In the early '60s, Arndt studied history and philosophy at the University of Minnesota, but began to study painting and drawing when he enrolled at the Minneapolis College of Art and Design. In 1970, after the Kent State killings, he dropped out of graduate school and began photographing the men, women and children of America.

He has spent years capturing images of the people of not only Minnesota, but also New York City, North Dakota, London, and Germany. Arndt has traveled extensively around America for the last 20 years photographing political conventions, block parties, parades, picnics, ethnic festivals, families, homeless people, old people, young people, black people, white people, rural life, and urban life. For the past five years, he has been photographing the people of Chicago while living there with his wife Susan.

This project evolved in 1988 out of his general body of work, after Lynne Sowder, then director of the First Bank Art Program in Minneapolis, noticed a theme about men emerging in his work. Arndt began to explore this theme, and since then has continued this vast exploration of the variety of men in America.

Education

Bachelor of Fine Arts, Minneapolis College of Art and Design, 1968
Attended University of Minnesota Graduate School, 1969-1971

Selected One Person Exhibitions

1993 *The London Series*, A Photographer's Gallery
1993 *Chicagoland*, Minneapolis College of Art and Design, Minneapolis
1992 *Men in America*, Art Institute of Chicago, Chicago
1989 Tartt Gallery, Washington, DC
1989 Photofind Gallery, New York
1989 Jon Oulman Gallery, Minneapolis
1984 *Tom Arndt's America*, Minneapolis Institute of Art, Minneapolis

Selected Group Exhibitions

1992 *At the Edge of Shelter: Homelessness in Chicago*, The Art Institute of Chicago
1987 *Changing Chicago*, The Art Institute of Chicago
1987 *Twelve Photographers Look at Us*, Philadelphia Museum of Art
1986 *Farm Families*, The Art Institute of Chicago
1982 *Twentieth Century Photographs from the Museum of Modern Art*, Seibu Museum, Tokyo, Japan

Fellowships

1986-87 Regents Park Fellowship, Chicago
1983 Minnesota State Arts Board Fellowship
1978 National Endowment of the Arts Fellowship

Commissions

1991 Homeless project, The Art Institute of Chicago and the Focus Infidelity Fund

1988 Men in America, First Bank System, Minneapolis

1987 Changing Chicago, organized by the Focus Infidelity Fund

1987 Percent for Art, the Minnesota State Arts Board. Permanent installation at the Minnesota State Office Building, St. Paul

1986 Farm Families, The Art Institute of Chicago and the Focus Infidelity Fund

Selected Permanent Collections

Museum of Modern Art,
New York
The Art Institute of Chicago,
Chicago
Minneapolis Institute of Art,
Minneapolis
Museum of Modern Art,
San Francisco
Hallmark Collection,
Kansas City, MO
Eastman House,
Rochester, NY
Los Angeles County Museum,
Los Angeles

Selected Articles and Photo Essays

"America Now," and "Chicago Now," *The Arts, Chicago Tribune,* 17 January 1993.

"Men in America, Who are They?" *The Arts, Chicago Tribune,* 5 January 1992.

"Changing Chicago," *Chicago Tribune Magazine,* 26 March 1989.

"Changing Chicago," *Chicago Tribune,* 7 April 1989.

"Dear Mother," (photographs by Thomas Arndt, text by Garrison Keillor,) American Photographer, July 1985.

"Politics as Usual," photographs of the Democratic Convention by Thomas Arndt and Robert Frank, American Photographer, November 1984.

"The Documentary Urge: Tom Arndt," Video documentary: narrated by Garrison Keillor, produced by the Minneapolis Institute of Art.

"Tom Arndt at the Democratic National Convention, San Francisco," National Public Radio, 1984, narrated by Bob Edwards.